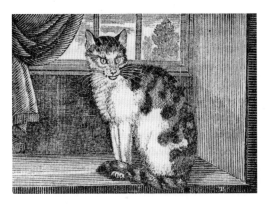

Puss in Books

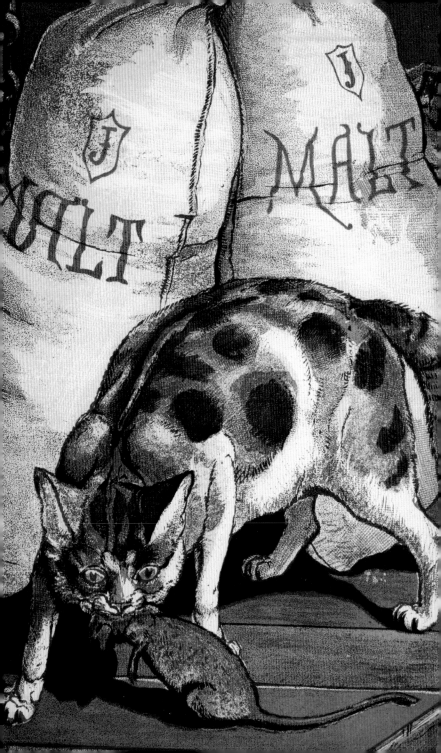

Puss in Books

CAT ILLUSTRATION
THROUGH THE AGES

Catherine Britton

THE BRITISH LIBRARY

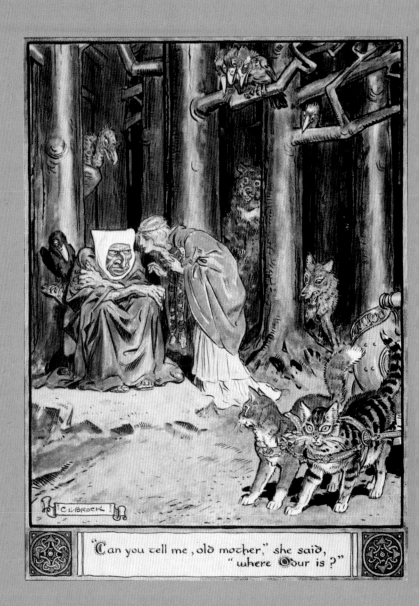

"Can you tell me, old mother," she said,
 "where Odur is?"

Above: Two cats pull the chariot of the Norwegian goddess Freya
From *The Heroes of Asgard, Tales from Scandinavian Mythology* by A. & E. Keary, 1930.
Colour lithograph by Charles Edmund Brock

Introduction

Unlike other domesticated animals, cats have changed very little under human influence. From about 1450 BC images of cats appeared on Egyptian tomb walls, behaving as they still do: sitting under a chair waiting for scraps of food; hunting snakes, birds and fishes. Since the civilization of Egypt was dependent on stored grain, the importance of keeping rats and mice out of granaries was paramount, and the cat became one of the most high-status animals in Egyptian culture, inspiring gods such as Sekhmet, with the head of a lion, and the more familiar cat goddess Bastet. Such was the importance of the domestic cat in Egypt that the whole family went into mourning when the family cat died. To Greek travellers in Egypt, who had never seen cats let alone kept them as pets, the Egyptians' reverence for the animals was perverse, and although the spread of domestic cats from the Middle East was inevitable, they were not valued in the same way by Greek and Roman societies.

By the time of the first extant collection of 100 of Aesop's fables in the first century BC, it was the fox, lion and ass who were the predominant animals, with dogs featuring in sixteen of the fables, and cats in only five.

In other cultures cats were beginning to feature in myths and folk tales, and to be associated with gods and deities. The Scandinavian goddess Freya travelled in a chariot pulled by two cats, which seems a little incongruous until one realises that the cats were not the usual *felis domesticus*, rather they were the much larger Norwegian Skogkatt, literally 'forest cat' which according to mythology were so heavy that even Thor the god of thunder could not lift them from the forest floor.

There are no examples of cats in the Bible, although there are a number of legends linking them to biblical events. It was said for example that during the time of the great flood, Noah's ark was overrun with rats. Noah prayed for a miracle, and a pair

of cats sprang from the mouth of a lion and lioness. These cats then caught and ate all the rats on the ark (except for the original two). When the flood receded and the animals came out on to dry land, it was the cats who led the procession out of the ark; this is why cats are considered to be the proudest of all animals.

By the Middle Ages the cat was established in western civilization as an efficient and useful rodent catcher. Manuscripts of the period show it playing with, or catching mice, or sometimes, in the convention of inverting the natural order of the world, medieval cats would be depicted being teased and hunted by mice and rabbits, who have temporarily gained the upper hand in the relationship between hunter and prey.

This is not to suppose that the cat's transition from household pest controller to cherished domestic companion was an easy one. The ambivalent nature of the human and cat relationship has been extensively recorded in literature. Cats are independent, nocturnal and clever animals, who hunt and kill without human supervision or approval. This aloofness and lack of subservience to their owners made it easy to impose moral judgements on to feline behaviour, and cats became the focus of animosity and horrible cruelty. Superstitions around feline behaviour became widespread, although often contradictory:

Above: A STRIPED GREY CAT FIGHTS WITH A SMALL WHITE DOG
From *The London Hours*, early fifteenth century

some people thought that having a cat sleeping on the bed warded off evil spirits, and others that a cat on a bed could suck out the breath of a sleeping person; in China the company of a cat indoors brought good luck, whereas in France it was thought that cats would bring ghosts into the house if they were let in at night. The belief that cats could see ghosts and demons was widespread, and stretched back at least as far as the Egyptians, who thought that cats stored sunlight in their eyes, which they would later use for seeing at night.

From associating cats with ghosts and spirits, it was a short step to seeing them as agents of the Devil. Abundant and largely valueless, cats became easy targets for malice and persecution. The writer Edward Topsell wrote in his 1607 book *The History of Four-Footed Beasts and Serpents and Insects* that cats 'have a peculiar intelligible language amongst themselves' and that at night their eyes 'can hardly be endured for their flaming aspect'. Finally, he claimed that 'the familiars of witches do most commonly appear in the shape of Cats, which is an argument that this beast is dangerous to soul and body.'

This association of witches with cats today seems quite consistent with the mysterious qualities that we now confer upon them. However it is worth remembering that in the sixteenth and seventeenth century it was considered that witches performed their deeds through any small animal, such as a mouse, toad, cat or dog. It is only through folk and fairy tales that the magical association of woman and cat becomes more common, presumably as mice and toads were less interesting than cats. Even in the nineteenth century there remained a lingering belief in the cat's supernatural connections. Sir Walter Scott, who was well known for his love of cats remarked: 'Ah! Cats are a mysterious kind of folk. There is more passing in their minds than we are aware of. It comes no doubt from being too familiar with warlocks and witches.'

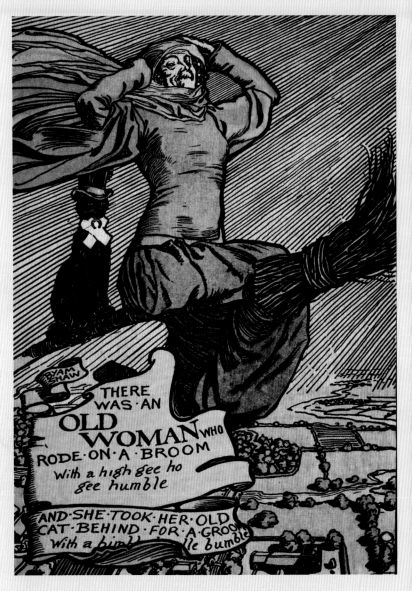

Above: A STYLISHLY-ATTIRED CAT GOES FOR A RIDE
'There Was an Old Woman Who Rode on a Broom',
from *Old King Cole's Book of Nursery Rhymes*, illustrated by Byam Shaw

Shakespeare also made use of cats' demonic reputation, as the witches in *Macbeth* hear the call of the cat which will invoke the spirits as they cast their spell: 'Thrice the brinded cat hath mew'd'. Elsewhere in his plays the cat is treated with little respect: in *Much Ado about Nothing*, Benedick casually jokes against his course of action: 'If I do, hang me in a bottle like a cat and shoot at me'. *The Tempest*'s Antonio suggests that some people will unthinkingly do as they are told, just as a cat will drink the milk she is given: 'For all the rest / They'll take suggestion as a cat laps milk.' The image of the hungry cat is also used in *Henry IV* as Falstaff states that 'I am as vigilant as a cat to steal cream.'

It was not until the end of the seventeenth century that animals, including cats, came to benefit from a more humane attitude. Cats were still economically important as rodent catchers, but the aristocracy began to adopt them as pets, and the fashion filtered through to the rest of society. The French story of 'The White Cat' is interesting in that it was published one year after Perrault published his version of 'Puss in Boots', yet it is radically different in its treatment of the cat. In the story three princes are sent out by their father to find a dog for him. Rather than finding a dog, the youngest prince befriends a cat, Blanchette, and instead of using her as a conduit to money and power (as was the case with 'Puss in Boots') the prince treats the cat with great gallantry. When the time comes to return to his father the prince declares 'Alas! I love you so dearly. Either become a woman, or else make me a cat.' Blanchette reverts to her original form – naturally she is a princess. What is unusual in the story is that the character of the cat princess remains the same, whether in feline or human form. The idea that a cat could be as virtuous and elegant as a lady was unheard of, and the story, written down by the Countess d'Aulnoy, became one of a number of tales to argue that animals

who follow their own nature live happy and natural lives.

Influenced perhaps by their aristocratic French friends, English writers such as Horace Walpole and Samuel Johnson also wrote openly of their affection for their pet cats. In 1783 James Boswell reported in his *Life of Johnson* that Johnson went out in person to buy food for his cat Hodge, in case his servant felt imposed upon and took a dislike to the cat. Hodge, Boswell said, scrambled 'up Dr Johnson's breast, apparently with much satisfaction, while my friend smiling and half-whistling, rubbed down his back, and pulled him by the tail; and when I observed he was a fine cat, saying "Why yes, Sir, but I have had cats whom I liked better than this", and then as if perceiving Hodge to be out of countenance, adding, "but he is a very fine cat, a very fine cat indeed".'

The new friendliness towards cats extended to nursery rhymes which were being published in collections such as *Tom Thumb's Pretty Song Book* and *A Pretty Little Pocket Book Intended for the Instruction of Little Master Tommy and Pretty Miss Polly*. Many rhymes and songs included cats, no doubt a reflection of their popularity as pets for small children.

One of the most famous and enduring cats in literature is that created by Lewis Carroll (whose real name was Charles Lutwidge Dodgson), the Cheshire Cat who mysteriously appears and disappears, leaving only his grin behind:

> Well I've often seen a cat without a grin, thought Alice, but a grin without a cat? It's the most curious thing I've seen in all my life!

The origins of the Cheshire Cat have been the subject of much speculation, including being based on local church carvings, or cheeses in the shape of cats, and the slang phrase 'to grin like

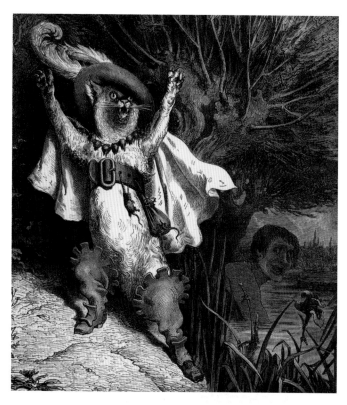

a Cheshire Cat' predates Carroll's work by many years. In the course of researching this volume a new theory has come to light, which is the local legend of a ghostly apparition which appeared less than two miles from where Carroll grew up in Croft-on-Tees with his seven sisters and three brothers. The theory, which is described in more detail on page 75, may or may not help to explain the origins of this literary cat, but it is hard not to imagine the young Dodgsons daring each other to walk down the haunted lane, so close to their family home, where the ghostly animal appeared bit-by-bit and became so well-known

Above: Puss in Boots
The magnificent frontispiece engraving by Doré from Perrault's *Les Contes de Perrault*, 1862

that it was described in detail in a history of the town in 1854.

In nineteenth-century novels, cats (just like other animals) were included as realistic creatures, presented to reinforce the qualities of their owners. Lady Jane, the large grey cat belonging to the unpleasant rag and bottle dealer Krook in Dickens' 1854 novel *Bleak House* embodies the predatory mid-Victorian society that he witnessed. Zola's *Thérèse Raquin* published in 1867 contains the cat Françoise, who witnesses Thérèse and her lover Laurent in her husband's bedroom. The lovers project their guilt at the murder of her husband on to the defenceless cat, and in the end Laurent 'persuaded himself that the cat knew all about the crime and would denounce him if ever a day came when he could speak'. Finally he flings the cat out of the window, breaking its back – a wholly evil act that generates more emotional impact than the earlier murder of Thérèse's husband.

As the tastes of the reading public became more diverse, so cats in twentieth-century literature were increasingly depicted as quasi-human characters, taking a central role in the narrative, and often able to talk, walk and behave much like their human protagonists. *Tobermory* by the Edwardian short story writer Saki has a cat who can suddenly talk, but remains catlike in his freedom from social conventions. The guests at the house party he is attending realise that the previously silent cat has been listening in to their private conversations, but unfortunately for them he has none of their bourgeois reserve in publicly repeating their hitherto private remarks. As the guests become more panicked at what he will say next, Tobermory remains entirely comfortable, the only one of the party true to his own nature.

In the 1929 darkly comic allegorical novel *The Master and Margarita*, the gun-toting and fast-talking giant black cat Behemoth is one of the retinue of the magician Professor Wolen (The Master). Behemoth can not only talk, he drinks vodka and

cuts off the heads of his enemies with undisguised relish. The novel was written during the worst years of Stalinist persecution, and remained unpublished in Russia for over thirty years after Mikhail Bulgakov died. Its comic-horrific depiction of a totalitarian city with 'disappearances', draconian security measures and 24-hour surveillance was enough to cause Bulgakov to fear for his life, and he even tried to destroy the half-finished manuscript at one point. Behemoth is one of the most memorable characters, a diabolical henchman of the magician, bringing anarchy and subversion to the tyrannised city, and helping to bring it crumbling down in anarchy and farce.

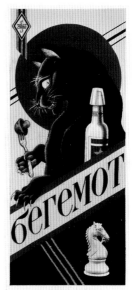

More recently, gently anarchic cats such as Simon's Cat and Splat the Cat have made readers smile with their all-too-human responses to their everyday dilemmas. The Harry Potter novels, created by J. K. Rowling, feature many cats who resemble their owners in various ways: Mrs Norris the distinctly unpleasant cat who patrols the corridors of Hogwarts with caretaker Argus Filch, and Crookshanks, the highly intelligent cat with a slightly squashed face who belongs to brainy Hermione Granger.

A book of this extent will never include all favourite cats of every reader, and there are some that it has not been possible to include. But for everyone who values the grace, independence and mystery of the cat, I sincerely hope you will find pleasure in these pages, hopefully reading them with a cat on your lap.

Above: A CONTEMPORARY REWORKING OF BEHEMOTH
From *The Master and Margarita* by the American artist Christopher Conn Askew

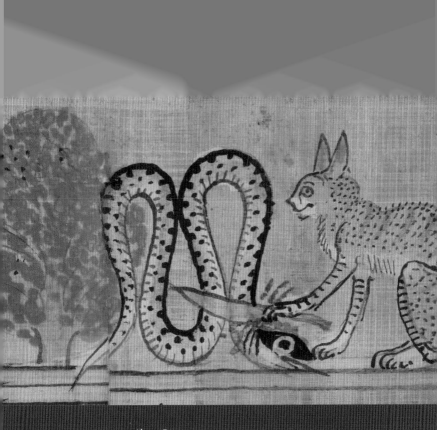

Above: Ra in the guise of a cat killing a serpent
From *The Book of the Dead* of Hunefer

Below: A papyrus with satirical vignettes in which animals mimic
human activities, but in a topsy-turvey world
On the right of the painting is a wild cat who walks upright like a
human herdsman, and cradles a gosling

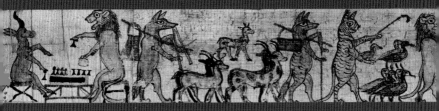

Egyptian Cats

The association of cats with ancient Egypt is well known. The north African cat *felis sylvestris libyca* was domesticated by the Egyptians four or five thousand years ago, and kept as a predator of the mice and rats which ate their valuable grain. As one of the few animals that could kill the poisonous snakes that were so common throughout the country, it was treated as a valued member of any household. From about 1450 BC images of cats appear on mummies, sarcophagi, statues and frescoes, usually shown as yellowy brown in colour, and with a striped tail. However, apart from tomb inscriptions there appear to be no Egyptian writings on cats, and we have to rely on the Greek historian Herodotus (and later Greek and Roman writers who travelled to Egypt) for written accounts of the animals, and the esteem in which they were held.

Like several other animals in ancient Egypt, the cat was associated with a deity: Bastet, the goddess of feminine allure, maternity and the home. Herodotus reported that the temple of Bastet in Bubastis was the most beautiful in Egypt, and the annual festival in her honour was both bawdy and very popular. He also famously noted that if a cat died, the entire family of the house in which it lived would shave off their eyebrows; interestingly, but less often reported, he also wrote that if their dog died the family would shave off all their hair. Four hundred years later another Greek historian, Diodorus Siculus, wrote of witnessing the lynching of a Roman who had accidentally killed a cat. Subsequent Greek and Roman historians were less impressed with the Egyptians' reverence and respect for the cat, as evidenced in the words of the fourth-century Greek poet and playwright Anaxandrides: 'You worship the cow, but I sacrifice it to the gods... you worship the bitch, I beat her when I catch her eating my best food...if you see a cat in any trouble you mourn, but I am very glad to kill and skin it'.

The Lindisfarne Gospels Cat

The religious life of contemplation, isolation and austerity has often been relieved by the quiet companionship of a cat. In the ninth century an unknown Irish monk wrote the short poem 'Pangur Ban', about his white cat:

> I and Pangur Ban my cat
> 'Tis a like task that we are at;
> Hunting mice is his delight
> Hunting words I sit all night...

Even earlier, in about 720 AD, the scribe Eadfrith wrote and illuminated the Lindisfarne Gospels in the north-east of England at the monastic community on Lindisfarne Island. The main text of the manuscript is a Latin version of the Four Gospels, and the opening page of each of the Gospels is elaborately decorated with ornamental calligraphy which includes large decorated initials, surrounded by complex designs of Celtic spirals, intertwined with birds and beasts.

On the opening page of St Luke's Gospel, the stylised but unmistakeable form of a large yellow cat appears crouching in the bottom right-hand corner of the page, its stomach full of several (whole) birds that it has already consumed, but still gazing intently at four more birds, blithely processing towards it at the bottom of the page. The details of the cat are perfectly rendered, from the ears, pricked and alert, to the individually-drawn claws of its paw – Eadfrith certainly knew his cats. He used local plant materials to create the colours used in the manuscript, in this case arsenic for the yellow head of the cat, lichens for the purple border and woad for the blue colour used for its leg. Nearly 1300 years since it was created, this conspicuous cat remains waiting to pounce, a small but colourful addition to one of the greatest examples of manuscript illumination.

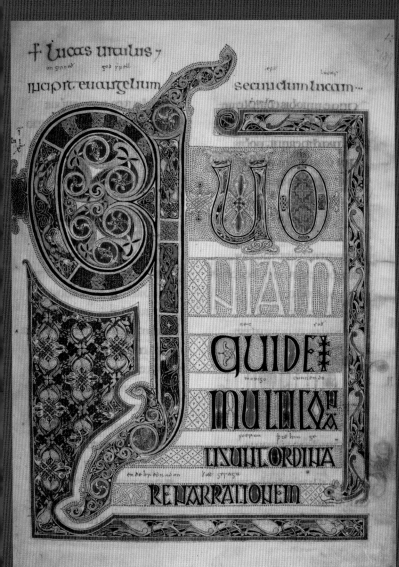

✝ lucas uralius ⁊

INCIPIT EUANGELIUM secundum lucam·⁖

QUO
NIAM
QUIDE✝
MULTICO
LISUNTORDINA
RENARRATIONEM

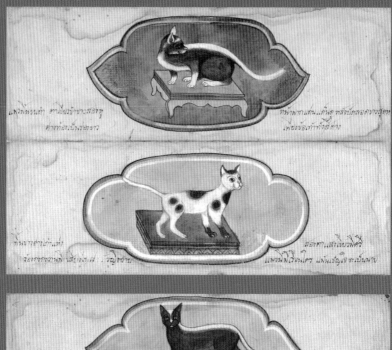

แมวสีทรงดำ ขาเป็นปข้างสองคู่
ดาวทั้งเป็นรอยขาว
ทั่วทากแก่น...ลันด หลังนัคสองศารสุดท
เพียงข้อเท้าทั้งสี่ข้าง

พันนารสานบ้านเท่า
จอระรุดรุวาหน้า เสียงวาเฝ้า ..วุญูข้าน
ลอกคา,เลวเล็บวงศีรี
แพงนมเรือนใคร แม้นเปนเจ้ะเปนนาย

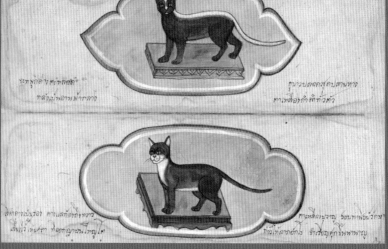

ชะพุกลำวตะสลดที
ทั้งดูพอาพ ฝ้าทลาง
รูบาวปลอดสุดปสานทาง
ดานเหลือทคำ ติกทั่วตัว

สัทตาวอนวอา ดาวแลท้อรุ้งทวาว
แม้นวิ.โทรศา ช่อยตกญาณในเหญูใต
ทายเหลือนุวาญ จอนทาพับน์วักษา
ทั่วไท้สลายอๆไง จักเช่บชุคุ๋บ่พพาหาญ

Siamese cats

Animals with specific colours or markings are often associated with good fortune for the owner, and in nineteenth-century Siam (or Thailand) it was considered lucky to own certain specific breeds and types of cats. The text of this Thai manuscript describes twenty-three cats, seventeen of which would bring fortune and good health to their owners. For example, a white cat with nine black spots, green eyes and a strong and beautiful voice was especially propitious, and would bring great prosperity to the owner, no matter how poor their original social status.

Certain other animals such as elephants (particularly albinos) and horses also had highly symbolic significance, especially for royalty, and Siamese cats were originally only bred for the royal family alone to own. When a person of high rank died, it was usual to select one of these cats to receive the dead person's soul. The cat was then removed from the royal household and sent to one of the temples to spend the rest of its days living a ceremonial life of great luxury, and revered as the keeper of this sacred space.

The nineteenth-century text has been identified as originating from the central area of Thailand, and was written on fine paper made from local mulberry trees, and the manuscript opens vertically in an accordion-like folded codex. The unknown scribe describes the features of each of the cats, and how each one would bring benefits (or not) to the owner. Amongst the less 'lucky' cats is a completely white cat, which if it also had fire-coloured eyes was thought to be so unlucky that people were advised not to even look at it, let alone to keep one as a pet.

Opposite: A NINETEENTH-CENTURY MANUSCRIPT (UNNAMED) FROM THE CENTRAL REGION OF THAILAND DEPICTS LOCAL BREEDS OF CAT

ostri in egypto non

t mirabilia tua: non

noies multitudinis

uerunt ascendentes

Medieval Cats

In the illuminated manuscript of the *Très Riches Heures du Duc de Berry*, created in France in around 1415, the illumination for the month of January shows the duke seated at a lavish banquet with his hunting dog at his feet. In contrast, the February illumination depicts the interior of a rustic hovel, where alongside two peasants warming themselves by the fire, a small cat crouches beside the hearth. The disparity is deliberate and underlines the different status of the two domestic animals. The idea that cats could be treated as pampered creatures, entitled to the same privileged lifestyle as the aristocratic hunting dog, was unheard-of in medieval Europe. The cat was defined as a household rodent killer, and treated according to its degree of usefulness in that capacity. As such, the cat in medieval manuscripts is most commonly portrayed hunting or catching mice and rats. Only much later did they gain any kind of protection from persecution and inhumane treatment, and start to be described as the well-loved pet that we now recognise.

The Luttrell Psalter, created in Lincolnshire in midland England between 1325 and 1335 contains numerous detailed representations of the Luttrell family and their retainers throughout their working year on the Luttrell estate. As well as beehives and bees, dogs guarding property and seeing off ne'er-do-well pedlars, the artists included a marginal detail of a grey tabby cat, sitting upright and playing with a plainly terrified mouse between its paws. The anatomical details of the cat are not quite right: its legs are too thin and the shape of the head is wrong, but the pose of the cat (and mouse) is absolutely right – this is clearly a scene that has been observed many times.

The cat's usefulness as an efficient predator of the rodents

Opposite: A GREY STRIPED CAT HOLDS A BROWN MOUSE IN ITS PAWS
From The Luttrell Psalter, England, circa 1325–35

which ate the precious store of grain and spread diseases through the human population meant that it did have some economic value. In tenth-century Wales the king, Hywel Dda, decreed that the value of a kitten before it opened its eyes was one penny, as a young cat its worth doubled to twopence, and by the time it reached adulthood as a regular mouser it was valued at fourpence. Furthermore, if anyone killed or stole the cat who guarded the royal granary, then that person was compelled 'either to forfeit a ewe, or as much wheat as would cover the cat when suspended by the tail'.

Inevitably the cat's charm and capacity for companionship meant that it was the animal that got a seat by the fire, or under the kitchen table where it could be both warm and well-fed. The thirteenth-century Franciscan monk Bartholomeus Anglicus, author of the encyclopaedic manuscript *De Proprietatibus rerum* (On the Properties of Things) incorrectly identified the etymology of the Latin terms for cat; however he was spot-on in his description of the cat's character and behaviour:

> He is a full lecherous beast in youth, swift, pliant, and
> merry, and leapeth …on everything that is to fore him….
> He is a right heavy beast in age and full sleepy, and
> lieth slyly in wait for mice: and is aware where they be
> more by smell than by sight, and hunteth and reseth on
> them in privy places: and when he taketh a mouse, he
> playeth therewith, and eateth him after the play. In time
> of love he is hard fighting for wives, and one scratcheth
> and rendeth the other grievously with biting and with
> claws….When his skin his burnt, then he bideth at home.

The idea that singeing or burning a cat's fur in order to keep them from straying from the house is a medieval custom that

has thankfully been abandoned. Another custom was to cut off its tail (see *The Owl and the Pussycat*, p.71). In Chaucer's tale of the 'Wife of Bath' from *The Canterbury Tales*, she explains that one of her husbands told her

> ...that I walk out like a cat;
> For whoso would singe the catte's skin
> Then will the catte well dwell in her inn, [house]
> And if the catte's skin be sleek and gay,
> She will not dwell in house half a day,

But the Wife of Bath is not afraid to speak her mind; she has caught five husbands and compares this one to a drunken mouse.

Above: Illustration of a cat looking down on a mouse and a weasel
Image from an English bestiary, circa 1170

Witches' Cats

In contrast to the revered status of the cat in Egyptian and Classical cultures, from the Middle Ages their 'otherness' laid them open to suspicion, and quickly to persecution. Harmless but mysterious, abundant yet solitary, valueless yet a cherished companion of many an elderly woman, the cat was an easy target for church and civil authorities to use to allay public anxieties and assert their own power. Cats were burned alive as placatory offerings for a good harvest, walled up above doors or behind fireplaces to safeguard houses from harm, and from the fifteenth century were tortured and killed alongside their female owners as agents of the Devil.

In the witch trials in England, Scotland and America in the sixteenth and seventeenth centuries, women accused of witchcraft were frequently supposed to change themselves into animals, or else performed evil deeds through a familiar – a small animal such as a dog, cat, hare or toad. In Salem, Massachusetts in 1679, Elizabeth Morse was tried as a witch since she attacked her neighbour in the form of a 'white thing like a cat' and after her neighbour had smashed the 'thing' against a fence it was discovered that the next day Elizabeth had visited the doctor to be treated for a wound to her head. In the east of England an Essex woman, Elizabeth Francis, was tried at Chelmsford where she confessed that her cat (inadvisedly named Satham) spoke to her 'in a strange hollow voice' and helped get her a husband, whom she later made lame.

By the time these horrible events filtered their way into folk and fairy tales it was the cat who was most often associated with the supernatural element of the stories – presumably since hares and toads were less interesting, and cats bonding with humans

Opposite: THE YOUNG WITCH JENNET URGES HER FAMILIAR,
THE CAT TIB, TO ATTACK HER VICTIM
In an illustration from *The Lancashire Witches*, 1854

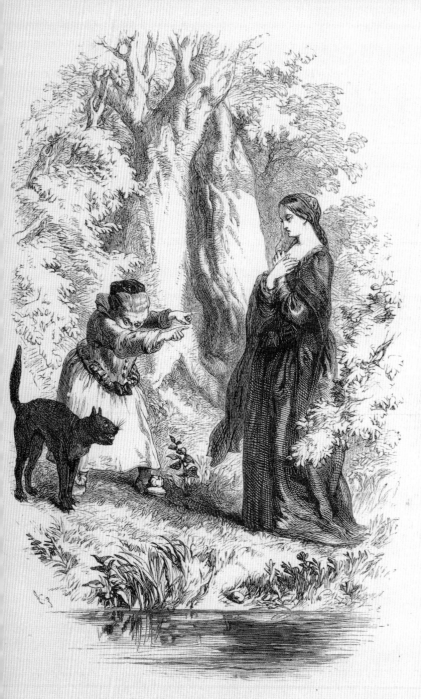

ALIZON DEFIES JENNET. p.308.

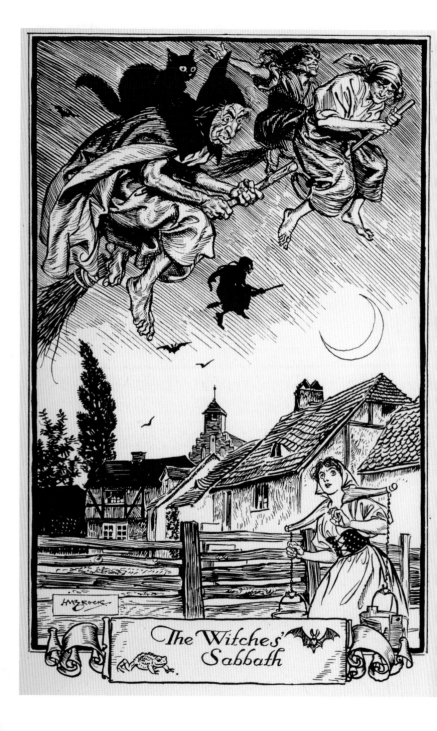

The Witches' Sabbath

is more obvious. The Norwegian writer and folklorist Peter Christen Asbjørsen wrote down the folk tale *The Haunted Mill* in 1888, in which a brave tailor volunteers to spend the night in a haunted mill which has burned to the ground twice before. In the middle of the night a number of black cats burst in and start to boil up a cauldron of pitch and tar. After twice stopping them from overturning the boiling tar, the tailor cuts off the right paw of one of the cats who has tried to attack him, and the cats run away. The next morning the tailor is telling the story to the miller and his wife, when he notices the woman hiding her right hand. 'Then the tailor saw plainly how things stood, but what he said to the man and what was done to the wife, I never heard.' Asbjørsen is careful to add Christian associations to the story: it takes place at Whitsun (the seventh Sunday after Easter and the day when Christ's spirit descended on the disciples) and the courageous tailor protects himself during his vigil by drawing a chalk circle about him, around which he writes the Lord's Prayer.

An even more overt example connecting cats with black magic comes from W.B. Yeats in 1888 in his *Fairy and Folk Tales of the Irish Peasantry*. In the story with the unavoidably-obvious title 'The Devil' a fisherman's wife in Connemara is furious when a large black cat comes in her cottage every night and devours all her best fish. The woman and her helper beat the cat with sticks, 'and struck hard blows enough to kill it, on which the cat glared at them, and spit fire; then, making a leap, it tore their heads and arms till the blood came, and the frightened women rushed shrieking from the house'. Eventually the woman goes back and throws holy water on the cat; 'no sooner was this done than a dense black smoke filled the place, through which nothing was

Opposite: A MILKMAID IS SURPRISED TO SEE A FLIGHT OF WITCHES OVERHEAD
From the 1924 edition of *The Golden Bough*, by Frazer, illustration by H.M Brock

seen but the two red eyes of the cat, burning like coals of fire'.

By the end of the nineteenth century writers came to value cats more highly, and in sophisticated society witchcraft was largely discredited. Connections between cats and witches became exotic, and the cat was seen as mysterious rather than evil. Cats and witches became subjects for children's literature, such as the charming 1942 story of *Gobbolino, The Witch's Cat*, by Ursula Moray Williams (Gobbolino is Italian for 'little hunchback'), and *Carbonel, the King of the Cats* by Barbara Sleigh, first published in 1955. More recent is Crookshanks, the cat with a 'squashed face' who belongs to Harry Potter's friend Hermione Granger. Author J. K. Rowling said that Crookshanks was inspired by a real cat she used to see on her lunch break when working in London in the 1980s : 'I became distantly fond of this cat, which prowled among the humans around it looking disdainful and refusing to be stroked. When I decided to give Hermione an unusually intelligent cat I gave him the appearance of this haughty animal, with the slightly unfair addition of bandy legs'.

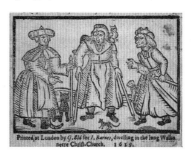

Above: A 1619 leaflet detailing 'THE WONDERFUL DISCOVERIE OF THE WITCHCRAFTS OF 'MARGARET AND PHILIP[A] FLOWER', WHO WERE EXECUTED AT LINCOLN, 11 MARCH 1618. Their familiars, a cat, a mouse and a dog can also be seen

Opposite: A MAN RIDING A CAT
A woodcut from *The Hexen Mystery*, 1545

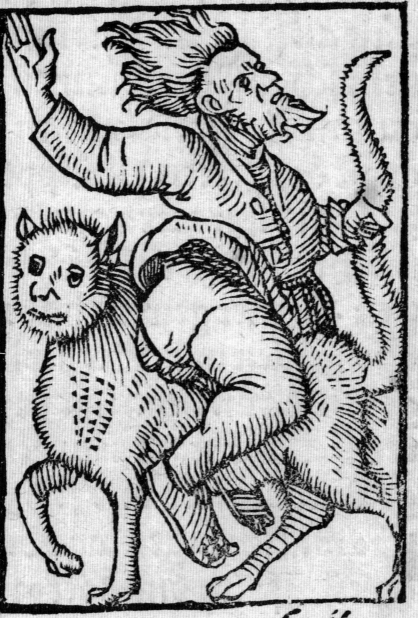

C ij

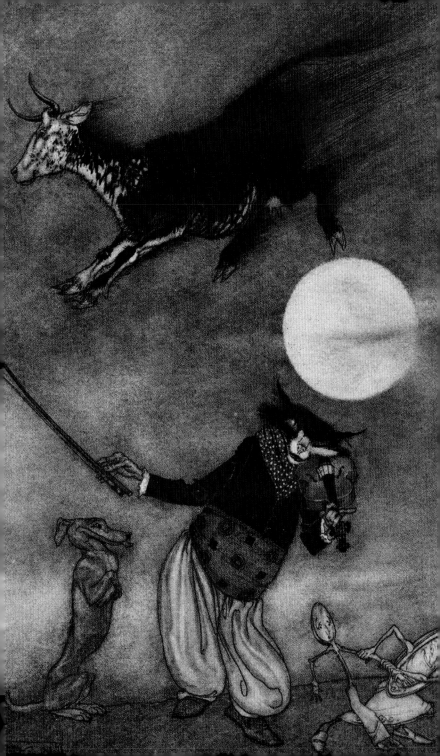

The Cat and the Fiddle

This nonsensical nursery rhyme first appeared in print in 1765 in *Mother Goose's Melody: or Sonnets for the Cradle*. Its origins and meaning are unknown, and there have been many attempts to rationalise the verse, including the theory that the cat and the fiddle is the first wife of Henry VIII, Katherine of Aragon, who was sometimes referred to as Katherine la Fidèle, (Katherine the Faithful), or possibly even Elizabeth I, who 'played' her ministers against each other.

It seems most likely that it is a simple nonsense poem, passed on through the oral tradition, and which varied slightly from generation to generation. The 1765 rhyme appears as:

> High diddle diddle, the Cat and the Fiddle, The Cow
> jump'd over the Moon;
> The little Dog laugh'd to see such Craft, And the Dish ran
> away with the Spoon.

By 1790 sheet music had been published by R Wornum as:

> Heigh Diddle Diddle the Cat and the Fiddle the Cow
> jumped over the Moon, Sir,
> The little Dog barked to see the sport and the Maid ran
> away with the Spoon, Sir.

In the *Infant Institutes* (1797) '..the dish lick't up the spoon', and by 1824 in Blackwood's edition '..the goats jumped over the moon... the cat ran away with the spoon.'

Arthur Rackham believed in the 'stimulating and educative power of imaginative, fantastic and playful pictures and writing

Opposite: THE EXOTICALLY-ATTIRED CAT FIDDLES IN 'HEY DIDDLE DIDDLE'
Illustrated by Arthur Rackham, from *Mother Goose: The Old Nursery Rhymes*,
1913, Heinemann

for children', and his strange, vividly-coloured illustrations can be both mysterious and disquieting to readers of any age. Indeed the art historian Kenneth Clark recalled: 'I sometime caught sight of his drawings before I was on my guard and they stamped on my imagination images of terror that troubled me for years.'

However, despite the strange and sometime gloomy settings for Rackham's watercolours, the characters within them are usually benign, and often rather beautiful. He made his illustrations twice the size they were to be reproduced, and once his artistic reputation became well-established, he tended to work at an even larger scale. In this case, the cat appears clothed in some rather fetching yellow pantaloons and purple slippers of a distinctly middle-eastern design, a fashionable influence echoed in the work of Rackham's contemporaries Edmund Dulac, Harry Clarke and Aubrey Beardsley.

Right: RANDOLPH CALDECOTT'S ILLUSTRATION
DEPICTS LIFELIKE FARM ANIMALS DANCING TO THE
FIDDLING CAT WHO IS CURIOUSLY ATTIRED IN A COAT
From *Hey Diddle Diddle and Baby Bunting*,
Routledge & Sons 1882.

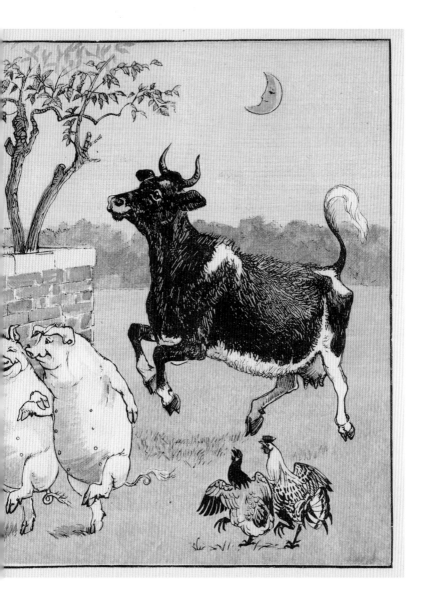

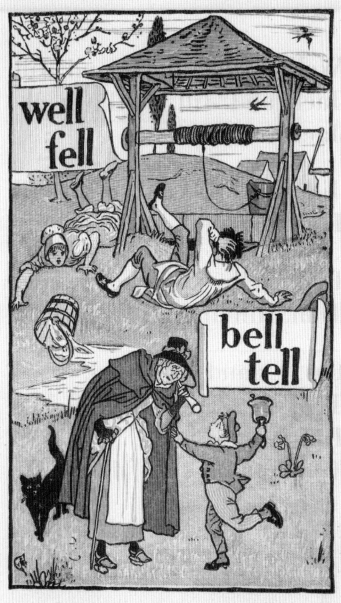

Above: The instructive illustration for 'Ding Dong Bell'
Illustrated by Walter Crane in *The Golden Primer*, published by Edward Evans, 1910

Ding Dong Bell

The origins and meaning of nursery rhymes are often hard to trace. Many were conceived purely as alliterative rhymes, helping children to acquire a love of words through the evocation of memorable – if often nonsensical – imagery. The poet Dylan Thomas summed this up when he was asked about his first memories of poetry: 'The first poems I knew were nursery rhymes, and before I could read them for myself, I had come to love just the words of them, the words alone. They were the notes of bells, the sound of musical instruments, the noises of wind, sea and rain.'

This idea of words as rising and falling sounds, linked to a simple narrative, is evident in 'Ding Dong Bell', which has been traced to 1580 when John Lant, the organist at Winchester Cathedral in the south of England recorded the rhyme:

> Jacke Boy, ho boy newes,
> the cat is in the well.
> let us now ring for her knell,
> ding dong ding dong bell.

By 1760 the verse had been printed in one of the first compilations of English rhymes, *Mother Goose's Melody*. It had by now evolved into a more familiar version, albeit curiously entitled 'Plato's Song':

> Ding dong bell
> The cat is in the well.
> Who put her in?
> Little *Johnny Green*.
> What a naughty boy was that,
> To drown poor Pussy cat.
> Who never did any harm,
> And kill'd the mice in his father's barn.

An interesting diversion to the history of this nursery rhyme came in 1834 when the English botanist John Bellenden Ker claimed to have 'discovered' that many nursery rhymes were originally written in a form of 'Low Saxon' or early Dutch – actually purely his own invention. He then 'translated' the rhymes back into English, and wrote that they had emerged from a kind of political protest literature, aimed at discrediting wealthy members of the clergy and monks. Thus 'Ding dong bell, The Cat is in the well', he decided was actually 'Ding d'honig beld, Die kaetst in de weld' and referred to the 'honig beld' or honey pot of wealth that the monks were keeping for themselves.

Aside from mad English botanists, the popular version of the rhyme was evolving in the nineteenth century to reflect the more widespread humane treatment of domestic cats. The revised version of 'Ding Dong Bell' now had little Tommy Stout pulling the poor cat out of the well before it drowned, and in some versions Pussy no longer 'killed the mice' but only 'played with' them.

A regional variant appeared in print in 1904 from the east coast of Scotland. It shifts the blame for the death of the cat to a boy and a girl, and ends with a specifically-timed invitation to the cat's funeral, extended to all that 'kent' or knew her:

> Ding dang, bell rang,
> Cattie's in the well, man.
> Fa' dang her in, man?
> Jean and Sandy Din, man.
> Fa' took her oot, man?
> Me and Willie Cout, man.
> A' them that kent her
> When she was alive,
> Come to the buralie
> Between four and five.

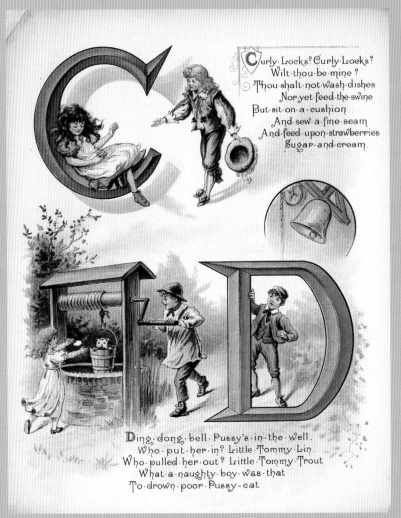

Curly·Locks? Curly·Locks?
Wilt·thou·be·mine?
Thou·shalt·not·wash·dishes
Nor·yet·feed·the·swine
But·sit·on·a·cushion
And·sew·a·fine·seam
And·feed·upon·strawberries
Sugar·and·cream.

Ding·dong·bell·Pussy's·in·the·well.
Who·put·her·in? Little·Tommy·Lin.
Who·pulled·her·out? Little·Tommy·Trout
What·a·naughty·boy·was·that
To·drown·poor·Pussy-cat

Above: A TYPICAL LATE VICTORIAN ILLUSTRATION
From *The ABC of Nursery Rhymes*, 1892

Christopher Smart's cat Jeoffry

FROM *Jubilate Agno (Rejoice in the Lamb)*

The poet Christopher Smart is often remembered more for being mad than for the quality of his verses. The year after Dr Samuel Johnson published his *Dictionary* in 1755, Smart, who had been a prize-winning undergraduate and Fellow of Pembroke College Cambridge, suffered his first bout of illness, which took the form of public prayer, wherever he was. Samuel Johnson remarked: 'My poor friend Smart showed the disturbance of his mind by falling upon his knees, and saying his prayers in the street, or in any other unusual place.'

Up until this point, thirty-two-year old Smart had earned a living through writing and editing, but had accumulated enormous debts on fine clothes and entertaining. However, his religious mania was to take over any thoughts of good living: 'I blessed God in St James Park till I routed all the company...the officers of the peace are at variance with me and the watchman smites me with his staff'.

By 1757 his illness was worse and his nephew observed that 'his various and repeated embarrassments acting upon an imagination uncommonly fervid, produced temporary alienations of the mind, which were attended by paroxysms so violent and continued as to render confinement necessary'. Smart was admitted to St Luke's Hospital for the Insane, and was subsequently moved to Mr Potter's private madhouse in Bethnal Green. It was whilst he was confined to Mr Potter's asylum that he composed his magisterial poem *Jubilate Agno* (*Rejoice in the Lamb*), which praises the Creator through a long list of animals, birds, plants, languages, people and figures from the Bible. Seventy-three verses of the poem comprise a long and detailed description of Smart's cat Jeoffry. These carefully-observed lines came from watching the behaviour of his only companion in the asylum, and who was obviously an esteemed friend:

For having consider'd God and himself he will consider
 his neighbour.
For if he meets another cat he will kiss her in kindness.
For when he takes his prey he plays with it to give
 it (a) chance.
For one mouse in seven escapes by his dallying.
For when his day's work is done his business more
 properly begins.
For he keeps The Lord's watch in the night against
 the adversary.
For he counteracts the powers of darkness by his electrical
 skin and glaring eyes.
For he counteracts the devil, who is death, by brisking
 about the life.
For in his morning orisons he loves the sun and the
 sun loves him.
For he is of the tribe of Tiger.

Jubilate Agno was not written for publication, and remained in manuscript form in a private library until 1939 when it was discovered by William Force Stead, an American diplomat and poet. It was later turned into a cantata by Benjamin Britten, who in May 1943 used eight verses of the poem for the choir and organ of St Matthew's Church Northampton, in celebration of the fiftieth anniversary of the church's conception. There were several objections to the selection of verses, but Britten was adamant: 'I'm afraid I have gone ahead and used a bit about the Cat Jeffrey [sic], but I don't see how it could hurt anyone – he is such a nice cat...Christopher Smart is a great inspiration and I hope you'll be pleased too.'

Overleaf: CORNELIS VISSCHER ENGRAVING OF 'THE LARGE CAT' CIRCA 1657.
The cat seems large because it fills the frame, and appears much larger than the
window, and appears oblivious to the mouse behind it

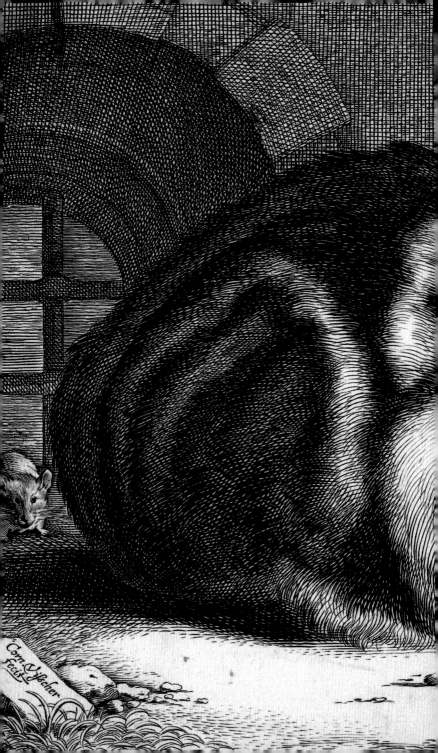

Corn. Bocher
fecit

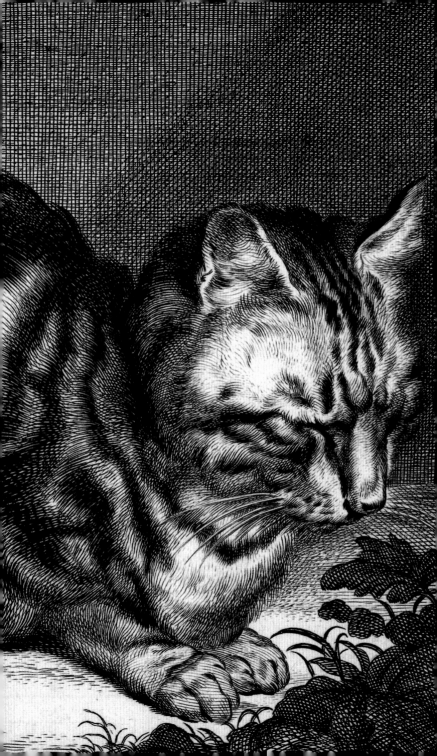

Ode on the Death of a Favourite Cat, Drowned in a Tub of Gold Fishes

Horace Walpole was a very fortunate young man. Son of the English prime minister Robert Walpole, he lived a life of wealth and privilege. His London house on Arlington Street was full of the latest examples of fashionable furniture and ornaments, including a large blue and white porcelain tub, imported from China as part of the contemporary craze for all things Chinese, including Chine tea, lacquer work, and Chinese motifs in architecture and garden design.

Walpole filled his tub with goldfish; another very new and exotic import, too new in fact for inclusion in Dr Johnson's *Dictionary* of 1755, the fish were first classified by the botanist Linnaeus in 1758 as *Cyprimus auratus* ('auratus' is Latin for gold).

However all this was of no practical assistance when in February 1747 one of Walpole's pet cats, a tabby called Selima, fell into the tub of goldfish, and unable to climb back up the steep slippery sides, was drowned. Walpole was understandably rather upset, and wrote to his friend the poet and Cambridge academic Thomas Gray to ask if he would write an epitaph for his lamented cat. Gray replied in the affirmative, but 'As one ought to be particularly careful to avoid blunders in a compliment of condolence, it would be a sensible satisfaction to me...to know for certain who it is I lament.'

By 1 March, Gray seems to have found out which of Walpole's cats had met with the unfortunate accident, and wrote to Walpole: 'There's a poem for you. It is rather too long for an

Opposite: IN THE FRONTISPIECE TWO CATS FISH FROM PAGODAS ON EITHER SIDE OF A LARGE MOUSE TRAP. THE MOMENT BEFORE SELIMA MEETS HER END IS FRAMED BY A RIVER GOD AND FATE CUTTING THE THREAD OF LIFE. BELOW THE SCENE THE MICE REJOICE
Richard Bentley's illustrations in the privately printed edition of 1753

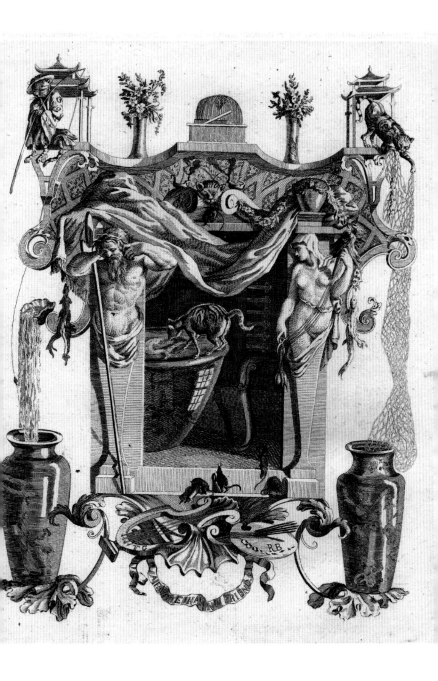

O D E

On the Death of a Favourite C A T,

Drowned in a Tub of Gold Fiſhes.

epitaph.' The poem he enclosed was what came to be known as Thomas Gray's *Ode on the Death of a Favourite Cat, Drowned in a Tub of Gold Fishes*, and after a small number of minor revisions, it was published in January 1748 by the bookseller Robert Dodsley of Pall Mall, London.

The clever combination of tragedy and comedy, constructed in a mock-heroic, mock-ballad, mock-morality tale – and all to memorialise Walpole's tabby cat – was quickly circulated around literary London, and several parodies and unauthorised sequels appeared. Cultivated readers may have enjoyed the Classical

Above: In the lunette above the poem, two cat pall-bearers with black crepe ribbons around their hats frame the scene of Selima's last moments as she flounders in the fish bowl
Richard Bentley's illustrations in the privately printed edition of 1753

references such as Alexander Pope's description of Helen of Troy, from his translation of *The Iliad*, as 'the brightest of the female kind' which Gray alluded to in feline form as 'Demurest of the tabby kind'. Other readers simply appreciated his perceptive description of the handsome cat as she watched the goldfish, flicking her tail in pleasure, unaware of her watery doom:

> Her conscious tail her joy declar'd;
> The fair round face, the snowy beard,
> The velvet of her paws,
> Her coat, that with the tortoise vies,
> Her ears of jet, and emerald eyes,
> She saw; and purr'd applause.

The fame of the poem increased substantially when it was included in an illustrated edition of Gray's poems in 1753, designed by Richard Bentley, a friend of Horace Walpole who had worked with him on his new house at Strawberry Hill. Bentley cleverly made the illustrations appear as though they were taken from fashionable works of art from the continent, but on closer inspection they incorporate witty details such as 'some mandarin cats fishing for goldfish', the figure of Destiny cutting the nine threads of the cat's life, and several playful mice running amok over the page.

Two years after Thomas Gray's death in 1771, Walpole had a Gothic pedestal (resembling a church font) built at Strawberry Hill, on which to place the original blue and white porcelain tub 'in which my cat was drowned' and it became one of the most prominently displayed *objets d'art* in the house. And at Pembroke College Cambridge (where Gray was a Fellow from 1756 until his death) there exists a living legacy to the poem, as almost every college cat is called Thomas (or Thomasina) Gray.

Cats and Royalty

Cats have rarely been associated with royalty. Since their domestication in Europe in the Middle Ages, they have been a familiar part of everyday life, most commonly living in houses and earning their keep as rodent catchers. They do not contribute to a lord or king's prestige like dogs or horses, and yet they are the household animal who gets to sit by the fire whilst the more 'noble' animals stay outdoors guarding the home, or stabled in outbuildings. And yet this is not to say that the cat may not aspire to greater things, indeed the saying 'a cat may look on a king'(first recorded in 1546) is as much a comment on the lofty indifference of cats to all about them as it is about the perceived equality of different creatures to one another.

In the same vein is the English nursery rhyme *Pussy Cat, Pussy Cat, Where Have You Been*, which was first published in London in 1805 in *Songs for the Nursery*. In this version the cat goes to London to 'look at the Queen' but ends up behaving in typical feline fashion by chasing a mouse:

> Pussy cat, pussy cat,
> Where have you been?
> I've been up to London
> To look at the Queen.
> Pussy cat, pussy cat,
> What did you there?
> I frightened a little mouse
> Under the chair.

In the rather more colourful Scottish version of the rhyme, the emphasis is on the outcome of the visit, as the clever cat ('baudrons' is generic Scottish dialect for cat) not only catches the mouse, but even thinks to save it in a 'meal poke', or food bag, to eat later:

Poussie, poussie, baudrons,
Where hae ye been?
I've been to London
Seeing the Queen.
Poussie, poussie, baudrons,
What got ye there?
I got a guid fat mousikie
Running up a stair,
Poussie, poussie, baudrons,
What did ye do wi't?
I put it in my meal-poke,
To eat it to my bread.

Above: ARTHUR RACKHAM'S PERENNIALLY CHARMING ILLUSTRATION
From the 1913 edition of *Mother Goose*, published by Heinemann

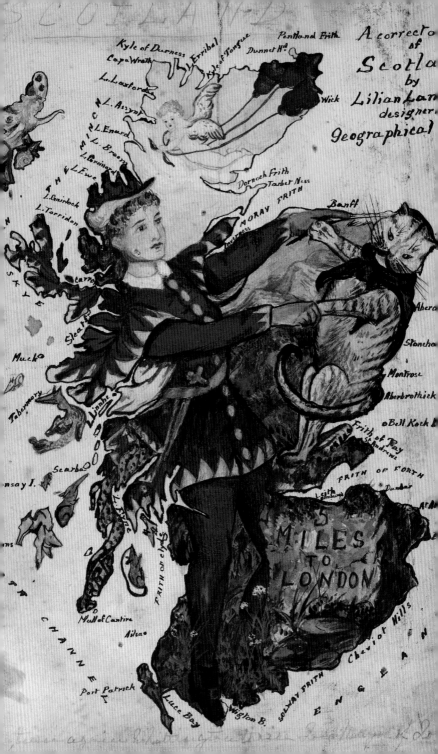

Dick Whittington's cat

The financial value of the cat as a predator of mice and rats – who carried pestilence and disease – has been documented since the earliest records of feline domestication. This monetisation of the cat's natural instincts is most evident in the legend of Dick Whittington, the ultimate story of a country boy finding great wealth in the City of London in medieval times. Although Dick Whittington's cat is part of the story (and is one of the most popular roles in the ubiquitous pantomime productions of the tale) there is no actual evidence for its existence.

According to the legend, Richard (or Dick) Whittington came to London from Gloucestershire and became a servant in the household of a rich merchant, Ivo Fitzwarren. Dick's only possession was his cat, bought for a penny. The cat proved to be a good mouser, and when Alderman Fitzwarren 'invited' the servants to contribute towards the cost of a trading expedition, the cat was the only thing Dick could donate. The merchant's ship stopped to take on provisions at a previously unknown and curiously feline-free part of the Barbary Coast (what is now Morocco, Tunisia, Algeria and Libya) where the captain made the acquaintance of the local king and queen, who invited him to dinner. However no sooner had the food been laid out on the rugs and carpets, when a huge number of rats and mice appeared and overran the banquet, spoiling the dishes. The shrewd captain, seeing a great business opportunity, quickly brought Dick's cat to the court, where it immediately killed dozens of the vermin. He then proceeded to sell the cat to the king for ten times the value of the ship's cargo. On his return to London, the

Opposite: A MAP OF SCOTLAND SHAPED LIKE DICK WHITTINGTON AND HIS CAT
A map entitled 'A Correct Outline of Scotland' by Lilian Lancaster from *Geographical Fun*,
Hodder and Stoughton, 1869

money from the sale of the cat enabled Dick to set himself up in business and - naturally – marry the daughter of his former employer.

The real Dick Whittington was never a poor servant – his grandfather was a knight, and although Dick was the third son in the family (and so would not inherit the title), he quickly became hugely wealthy through astute trading in silks, woollens and velvets, much of which was sold to the royal court: between 1392 and 1394 he sold goods to King Richard II worth in today's terms over £1.5 million/$2.3 million. Even the deposition of Richard II could not halt his commercial success. Whittington lent the new King, Henry IV, substantial sums of money and was rewarded with advantageous trading terms which included not paying tax on the export of wool. He also famously became Mayor of London three times: in 1397 (under Richard II); 1406 (under Henry IV) and 1420 (under Henry V).

But what of the real Dick Whittington's cat? The story of the cat being sold to a king is certainly a myth, and there are numerous folk tales from Europe, Persia and India of poor orphan boys being assisted by their pet cat to make their fortune – including of course Puss in Boots. In 1949 an attempt to find the tomb of Dick Whittington was made at the church of St Michael Paternoster Royal in the City of London, where it was known he was buried in 1423. No grave was found, but a small mummified cat was discovered...

Opposite: THE CAT POUNCES ON THE TROUBLESOME MICE, HELPING TO
SECURE DICK WHITTINGTON'S FORTUNE
From *English Fairy Tales*, retold by F.A.Steele and illustrated by Arthur Rackham,
Macmillan, 1918

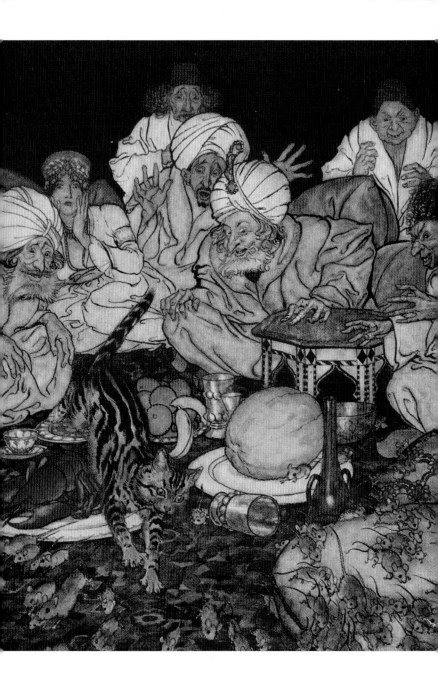

The Cat and the Mouse in Partnership

Cats are superb hunters. Infinitely patient, they creep slowly up to their prey, waiting for the perfect moment to pounce. This idea of 'sneaking up' to their target has given them a reputation for being sly and underhand. It has found its way into folk tales, and even Aesop (born approximately 620 BC), recorded fables featuring cats behaving in deceitful ways: one who feigned death to fool mice, and one who disguised itself as a doctor in order to catch some sickly mice on a farm.

Many centuries later the Brothers Grimm travelled throughout what we now refer to as Germany (and part of France) in order to collect and record traditional tales. Once again the sly cat is much in evidence, not least in the story of the cat and mouse in partnership. In this tale the cat pretends to be the friend of the mouse, and together they acquire a large pot of fat as a source of food for the winter. The pot is safely stored in the local church and all seems well until one day the cat is hungry, and not wanting to go to the bother of catching its supper, it tells the mouse that it has business elsewhere, and sidles off to the church to eat the top layer of fat from the pot. Having successfully deceived the ignorant mouse the cat repeats the ruse twice more. Winter comes and the mouse suggests to the cat that they go and retrieve their sustaining store of fat from the pot. Of course once they get to the church they find that the pot is empty. When the mouse tries to chastise the cat for being greedy, the cat reverts to type, and the poor mouse meets its inevitable end.

Opposite: 'THE CAT STOLE AWAY BEHIND THE CITY WALLS TO THE CHURCH'
From the 1909 The Fairy Tales of the Brothers Grimm illustrated by Arthur Rackham.

AUGUSTUS HARRIS'S
PANTOMIME.
PUSS IN BOOTS
DRURY LANE.

C. J. CULLIFORD & SONS, 2ª FIELD COURT, LONDON.

Puss in Boots

Fairy tales come in many different forms, but one common feature of their structure is the deserving and essentially good character of the central figure in the tale. A notable exception is the story of *Puss in Boots*, in which a miller's son (and not even the oldest son) acquires wealth and a royal title by the stealth and cunning of his cat, who was the only possession left to him on the death of his father. Of course Puss is no ordinary cat, and immediately persuades his new master to give him a bag and a fetching pair of boots, 'so that I may scamper through the dirt and brambles, and you shall see that you have not so bad a portion of me as you imagine.' The clever cat then uses the bag to catch rabbits, which he presents to the king as a gift from his master, the grandly-named Marquis of Carabas. His unscrupulous trickery continues as he persuades the king that the 'Marquis' owns most of the country, and then procures a castle from a terrifying ogre, who Puss persuades to turn himself into a mouse, whereupon he pounces on the ogre and eats him up. The famous boots are almost his downfall, as in the process of evading the ogre (who first turned himself into a lion) Puss slips and slides on the castle roof as his boots fail to grip the slippery tiles.

Why make a cat wear boots? One theory is that they may be a whimsical allusion to the markings on cats' feet (as in Bill Clinton's cat, Socks), although it is more believable that the boots are indicative of the cat's claim to human status. Clothes and shoes are always important elements of fairy stories (for example *Cinderella*, or the *Elves and the Shoemaker*) and this is no exception.

Puss in Boots was first published by Perrault in Paris in January 1697 as 'Le Chat Botté' within his collection of eight

Opposite: A LONDON PANTOMIME POSTER FROM 1885

tales collectively entitled *Histoires ou Contes du temps passé*, although a version of the story had appeared in an earlier collection from Italy. In the meantime Perrault's version of the story had been translated into English by Robert Samber and published in 1729 as *Histories or Tales of Past Times by M Perrault*. Since then, innumerable versions of the story have been told.

One memorable revision was that by the Victorian artist and illustrator George Cruikshank, in his *Fairy Library*, published between 1823 and 1824. In it he attempted to 'correct' what he regarded as immoral elements of the story, so for example it begins with the retirement of the miller who leaves the prosperous business in equal shares to his three sons. Later on, where Perrault previously described Puss as cleverly tricking the evil ogre out of his castle and lands, Cruikshank informs the reader that the cat had in fact restored the fortune of the miller, as the ogre had usurped them from him some years ago. Most recently *Puss in Boots* has been appropriated by Dreamworks in the animated film of 2011, which reverts to the original idea of Puss as a suave and swashbuckling confidence trickster.

Opposite: Puss (not yet booted) befriends the miller's son
illustration by Walter Crane from the 1873 edition of *Puss in Boots*, Routledge

Overleaf: Puss entertains the giant with some tall tales
From *Les Contes de Perrault*, 1862, illustrated by Gustave Doré

rd had the cat,
e cried out,
Alas!"

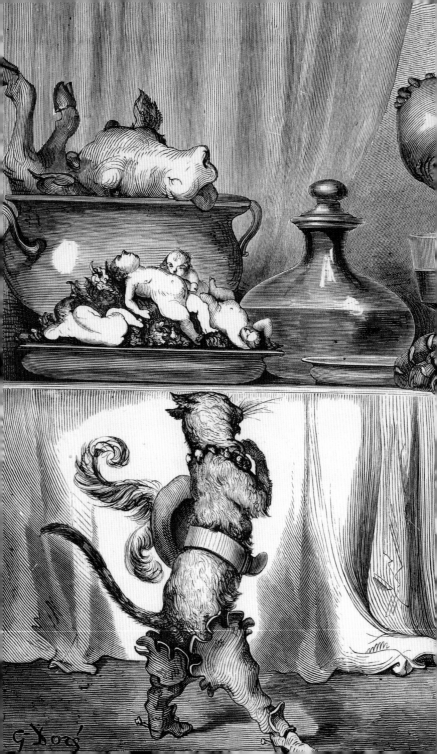

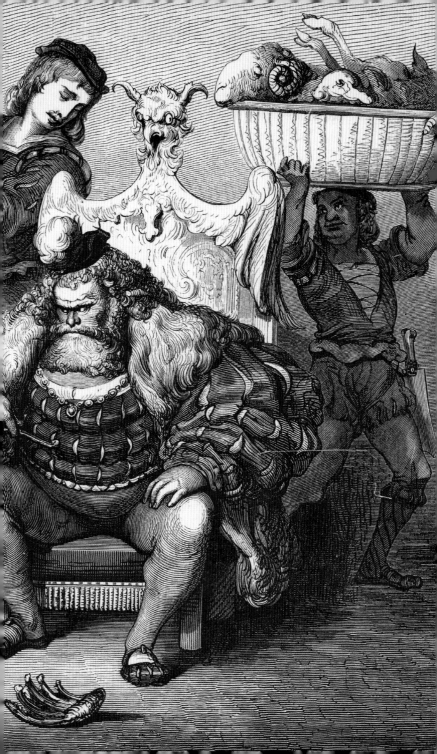

The Lord Chancellor Copies from Memory.

Lady Jane

FROM *Bleak House*

Charles Dickens wrote from observation and experience. As a young man he worked as a journalist, writing reports of parliamentary debates, political meetings and court-room cases, and the theme of social injustice, in particular the idea that the legal system operated in a way that oppressed ordinary people, was one to which he returned time and time again.

In his 1854 novel *Bleak House*, the law's delay and the problems of money and inheritance form the central themes of the book. The merciless destructiveness of the Chancery courts of law, who ruin the lives of the weaker members of society through the prolonged and expensive cases, are mirrored in the domestic circumstances of the rag and bottle dealer Krook, whose cat, Lady Jane, is just as ruthlessly unpleasant as her master:

> A large grey cat leaped down from some
> neighbouring shelf on his shoulder, and startled us all.
> 'Hi! show 'em how you scratch! Hi! Tear my lady!'
> said her master.
> The cat leaped down, and ripped at a bundle of rags
> with her tigerish claws, with a sound that it set my teeth
> on edge to hear.
> 'She'd do as much for any one I was to set her on,'
> said the old man. 'I deal in cat-skins among other general
> matters, and hers was offered to me. It's a very fine skin,
> as you may see, but I didn't have it stripped off! THAT
> warn't like Chancery practice though, says you!'

The cat's demeanour is so similar to that of Krook that they

Opposite: Lady Jane the grey cat winds itself around the neck of her master, the sinister Krook
From *The Biographical Edition of the Works of Charles Dickens*. Illustrations by Phiz, published in fourteen volumes by Chapman and Hall 1905

could be interchangeable: ' "His room – don't look rich" says Krook, who might have changed eyes with his cat, casting his sharp glance around.'

Miss Flite, who lives in the rooms above Krook, has been ruined by the courts, her last vestiges of hope living on through her caged birds, who may one day be set free. Just as the liberty of her birds is postponed, so the reader is led to examine the murderous intentions of the cat:

> 'I cannot admit the air freely,' said the little old lady –
> … 'because the cat you saw downstairs, called Lady
> Jane, is greedy for their lives. She crouches on the
> parapet outside for hours and hours. I have discovered,'
> whispering mysteriously, 'that her natural cruelty is
> sharpened by a jealous fear of their regaining their
> liberty … She is sly and full of malice. I half believe,
> sometimes, that she is no cat, but the wolf of the old
> saying. It is so very difficult to keep her from the door.'

Krook eventually meets a grim end, perishing in the bizarre circumstances of spontaneous combustion. Lady Jane unwittingly becomes a crucial part of the plot, as letters are found hidden in her bed which form the key to solving the court case.

Despite his depiction of the cat as a malign creature, at home Dickens nearly always kept cats as pets. His favourite was the rather plain-sounding Bob, who allegedly used to snuff out the candle on Dickens' desk to get his attention. After Bob died in 1862, one of his paws was preserved and made into the handle of a letter opener (now held in the New York Public Library), one of the more macabre of Dickens' artefacts.

Opposite: KROOK MEETS HIS HORRIBLE END, THE ONLY EXAMPLE OF SPONTANEOUS COMBUSTION IN LITERARY HISTORY

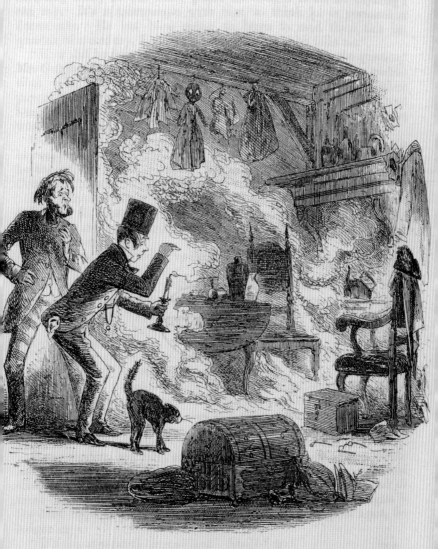

The Appointed Time.

Simpkin

The Tailor of Gloucester is unusual amongst the stories of Beatrix Potter in that it is set within a specific time and place: the city of Gloucester in the west of England, and in 'the time of swords and periwigs and full-skirted coats', about 1735–85. In 1894 (or possibly slightly later) Potter was visiting friends, and heard the story of the overworked Gloucester tailor, a Mr Pritchard, who publicly voiced his worries about not being able to finish a waistcoat for the local mayor. His two apprentices, hearing of his concern, let themselves into his workshop that night and finished the waistcoat for him, complete except for one buttonhole, as they had run out of thread (or twist). Pritchard was so pleased at what they had done that he put a notice in his shop window saying 'Come to Pritchard where the waistcoats are made at night by the fairies'.

Inspired by this, Potter reworked the story with the human apprentices replaced by mice, and she carefully researched the embroidery by making sketches of the waistcoats on display at what is now the Victoria & Albert Museum in London. In Potter's tale, the mice are trapped under some teacups by the tailor's tabby cat, Simpkin. The kindly tailor releases them, and in return they work through the night to finish sewing the mayor's waistcoat.

As is often the case in Potter's stories, the animals behave in a way that mixes up the natural and unnatural: Simpkin catches and plays with the mice like any predatory cat, and casually imprisons them, no doubt to finish them off later for his supper. However when his master needs him to go out to purchase provisions he is perfectly obedient and trots out to find bread, milk, sausages and 'one penn'orth of cherry coloured silk'. Later when he sees what a fine job the mice have done he goes away 'considering in his mind...and he felt quite ashamed of his badness compared to those good little mice!', which must surely constitute a unique case of a cat feeling remorse towards its prey.

The finished story was published in December 1903. Amongst the reviews was one by the trade journal *The Tailor and Cutter* who pronounced it as 'by far the prettiest story connected with tailoring that we have ever heard', a response which astonished and delighted her. Throughout her life she always maintained that of all her books, her favourite was the tale of Simpkin, the mice and the tailor of Gloucester.

Above: SIMPKIN RETURNS FROM HIS SHOPPING TRIP
From *The Tailor of Gloucester*, Frederick Warne, 1903

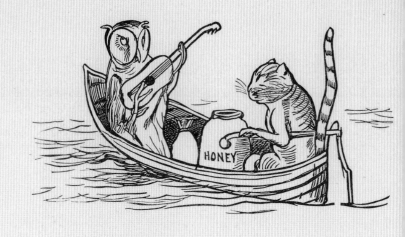

THE OWL AND THE PUSSY-CAT.

I.

THE Owl and the Pussy-Cat went to sea
 In a beautiful pea-green boat,
 They took some honey, and plenty of money,
 Wrapped up in a five-pound note.
The Owl looked up to the stars above,
 And sang to a small guitar,
"O lovely Pussy ! O Pussy, my love,
 What a beautiful Pussy you are,
 You are,
 You are !
What a beautiful Pussy you are !"

The Owl and the Pussycat

The most famous piece of nonsense verse in the English language was written by Edward Lear in December 1867 and was published in 1870 in *Nonsense Songs, Stories, Botany and Alphabets*. Whether or not the poem has any meaning or significance is doubtful, although broadly speaking it falls within the group of Lear's longer narrative poems concerned with wandering and travels to imaginary lands, other examples being *The Jumblies*, *The Duck and the Kangaroo* and *The Story of the Seven Families from the Lake Pipple-Popple*. Like all his verses, *The Owl and the Pussycat* is characterised by Lear's irreverent view of the world in which, as George Orwell observed, he expressed 'a kind of amiable lunacy, a natural sympathy with whatever is weak and absurd'.

The poem is completely fantastical, yet Lear manages to include enough realistic details (the pair take food and money on their journey) to allow a semblance of normality amongst the nonsensical narrative of the verse. Furthermore their story is charmingly and happily concluded, as the graceful cat and her bird-husband dance hand in hand by the light of the moon. The illustrations that Lear created for the poem are also broadly anatomically correct – the cat sits with her tail elegantly swept up out of the pea green boat, and then waits attentively for the turkey who lived on the hill to pronounce them man and wife.

Edward Lear went on to write a sequel to *The Owl and the Pussycat*, which was never completed and was published posthumously in 1938:

Opposite: THE ORIGINAL LINE DRAWINGS BY EDWARD LEAR
From the first edition of *Nonsense Songs and Alphabets*, published by Routledge, 1871

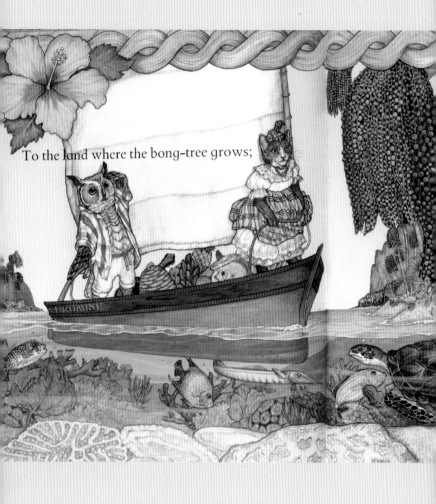

To the land where the bong-tree grows;

Above: The Owl and the Pussycat sail towards
'the land where the bong-tree grows'
Jan Brett's colourful interpretation of the poem,
Penguin Books, 1991

THE CHILDREN OF THE OWL AND THE PUSSYCAT

Our mother was the Pussy-cat,
Our father was the Owl,
And so we're partly little beasts
and partly little fowl,

The brothers of our family
Have feathers and they hoot,
While all the sisters dress in fur
and have long tails to boot.

Whether or not Edward Lear was inspired by the happy cat of his original poem is unknown, but in 1873 he acquired a tabby kitten he called Foss, who featured in many of Lear's later drawings, despite being rather portly and unattractive. Unfortunately Foss only had half a tail, as one of Lear's servants cut it off, thinking that would stop him from straying; but the cat was evidently a great source of comfort to his master, so much so that when Foss died at the age of seventeen he was buried with a large tombstone in the garden of Lear's Italian villa. Edward Lear himself died only two months later in January 1888.

The Cheshire Cat

FROM *Alice in Wonderland*

There are many strange and wonderful creatures in the 1865 classic story of *Alice in Wonderland*, not least the mysterious grinning Cheshire Cat which appears and disappears at will. There is no plausible explanation as to why the Cheshire Cat grins, and the author Lewis Carroll merely compounds the question when Alice first meets the terrifying Duchess:

> 'Please would you tell me,' said Alice, a little timidly, for she was not quite sure whether it was good manners for her to speak first, 'why your cat grins like that?'
> 'It's a Cheshire cat,' said the Duchess, 'and that's why. Pig!'
> She said the last word with such sudden violence that Alice quite jumped; but she saw in another moment that it was addressed to the baby, and not to her, so she took courage, and went on again:
> 'I didn't know that Cheshire cats always grinned; in fact, I didn't know that cats COULD grin.'
> 'They all can,' said the Duchess; 'and most of 'em do.'

It is well known that Lewis Carroll (Reverend Charles Lutwidge Dodgson) did not invent the term 'Cheshire Cat' himself, as there are citations of it that predate his books. John Wolcot, the poet and satirist, who wrote under the pseudonym of Peter Pindar, included it in his Works, published between 1770 and 1819: 'Lo! like a Cheshire cat our court will grin'. Earlier still, *A classical dictionary of the vulgar tongue* by Francis Grose (London, 1788) contains the following entry:

Opposite: ANOTHER MYSTIFYING ENCOUNTER WITH THE CHESHIRE CAT
Illustrations by John Tenniel from *The Nursery Alice*, the shortened, adapted edition of *Alice's Adventures in Wonderland* by Lewis Carroll, published by Macmillan, 1890

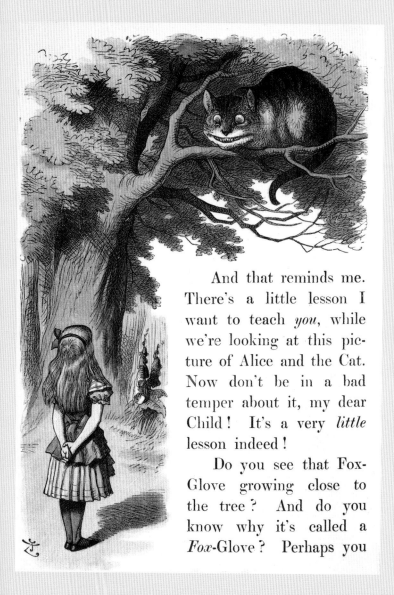

And that reminds me. There's a little lesson I want to teach *you*, while we're looking at this picture of Alice and the Cat. Now don't be in a bad temper about it, my dear Child! It's a very *little* lesson indeed!

Do you see that Fox-Glove growing close to the tree? And do you know why it's called a *Fox*-Glove? Perhaps you

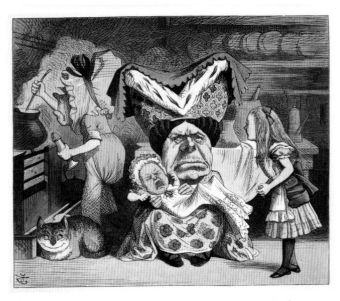

'CHESHIRE CAT. He grins like a Cheshire cat; said of any one who shows his teeth and gums in laughing.'

William Makepeace Thackeray also used the description well before Dodgson, in *The Newcomes; memoirs of a most respectable family*, (London, 1855) when Mr Newcome says to Mr Pendennis: 'That woman grins like a Cheshire cat.'

There is another explanation which comes from Dodgson's childhood, when his father was made Rector of Croft-on-Tees in the north-east of England. In the church, which the young Charles would undoubtedly have known very well, is a sedilla, which is a stone seat for the clergy, built into the wall. At one end of the seat is a carving of a cat (or possibly a lion) which when viewed from the pews appears to smile, which then 'disappears' when you stand up and view it from a different angle.

Furthermore in the course of researching this volume, a

Above: ALICE AND THE DUCHESS. THE CHESHIRE CAT SITS SMIRKING BY THE FIRE
From *The Nursery Alice*

new theory has come to light, relating to a local legend from Glassensykes in Darlington, less than two miles from Dodgson's childhood home in Croft-on Tees. In *The History and Antiquities of the Parish of Darlington*, by W Hilton Dyer Longstaffe, published in 1854, there is a reference to local ghosts which appear variously as 'white cats, white rabbits, white dogs, black dogs'.

There then follows an account of 'An old gentleman of Darlington [who] was at the witching hour of midnight returning from Oxneyfield....when he came to the place where the road to Harewood Hill now turns off, he looked back and was greatly surprised to see a large animal's head popped through the stile at the commencement of the footpath....Next came a body. Lastly came a tail.'

This slow revealing of the ghostly animal is reminiscent of the equally measured disappearance of the Cheshire Cat after Alice meets it for the second time:

> 'I wish you wouldn't keep appearing and vanishing so suddenly: you make one quite giddy.'
> 'All right,' said the Cat; and this time it vanished quite slowly, beginning with the end of the tail, and ending with the grin, which remained some time after the rest of it had gone.

One has to wonder if this local legend was known to the young Dodgson, and if so whether it influenced his characterisation of this famous cat? Whatever the origins, the iconic cat has appeared in numerous cartoons, films and books. In Jasper Fforde's *Lost in a Good Book* (2002) the Cheshire Cat is now the curator of 'The Great Library' which stocks not only all the books ever written, but also all those still to come, and even the books that will never be published. Dodgson would surely have approved of that.

The Black Cat

By the middle of the nineteenth century, cats were well established in literature as objects of affection. In Edgar Allan Poe's 'The Black Cat', written in 1843, the reader is made to feel intense sympathy at the murder of Pluto, the black cat.

Poe's narrator degenerates from an initially kind man ('I was noted for the docility and humanity of my disposition') into an alcoholic abuser of anyone who irritates him, and one day whilst intoxicated gouges out Pluto's eye. The act is described in horrible detail and he tries to explain his behaviour: 'who has not...found himself committing a vile or stupid action, for no other reason than because he knows he should not?' This twisted justification means that when he then hangs the poor cat, he again feels little remorse. Clearly we are in the midst of a descent into madness: first his house burns down, and then the image of the murdered cat appears in the ruins. Finally he is tripped on the stairs by his new cat. In anger he goes to strike the animal with an axe, but when his wife steps in to protect the cat he rounds on her and kills her. In a panic he conceals her body in the newly-built cellar and walls up the very-much-alive cat in with her. When the police come to investigate his wife's disappearance it is the howling cat that alerts them to the location of the rotting corpse and the cat. Interestingly it is the mutilation and murder of Pluto that is presented with the greatest emotional force, and the reader is led to feel more sympathy for the cat than for the nameless entombed wife.

The sense of darkness and psychological disturbance was a perfect source of inspiration for the Irish illustrator Harry Clarke, whose 1919 illustrations for Poe's *Tales of Mystery and Imagination* (which included 'The Black Cat') was to be his enduring masterpiece. *Studio* magazine called them flesh-creeping, brain-haunting illusions of horror, terror and the unspeakable', whilst the *Irish Times* described the drawings as having 'a dark and jewelled magnificence, terror and wonder'.

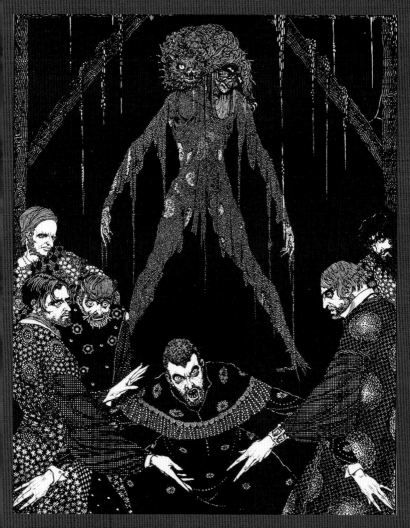

Above: THE COFFIN IS OPENED TO REVEAL THE ROTTING CORPSE AND THE BLACK CAT
From *Tales of Mystery and Imagination* by Edgar Allan Poe,
illustrated by Harry Clarke, Harrap, 1919

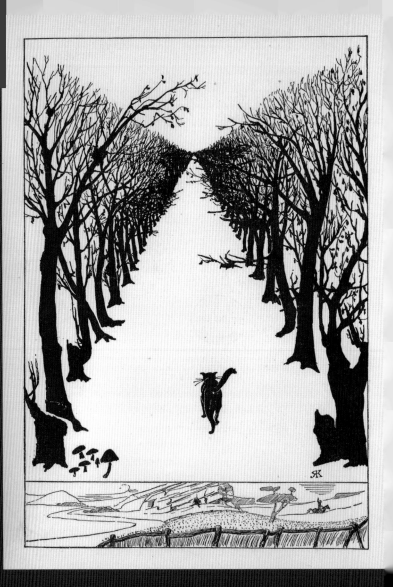

Above: Kipling's own interpretation of 'The Cat That Walked by Himself'
From *Just So Stories for Little Children* by Rudyard Kipling, Macmillan, 1902

The Cat That Walked by Himself

The iconic black-and-white illustration of the lone cat 'walking by his wild lone through the Wet Wild Woods and waving his wild tail' is all the more striking as it was created by Kipling himself. It was made to illustrate the short story 'The Cat That Walked by Himself', and appeared in the *Ladies' Home Journal* in 1902, then in book format later the same year, within the collection of short stories *Just So Stories for Little Children*, published by Macmillan.

All the *Just So* stories deal with imagined questions children might ask about animals' behaviour and appearance, such as why elephants have trunks, leopards have spots, or cats refuse to come when they are called. 'The Cat That Walked by Himself' is the longest story in the collection, and is the tale of the beginning of domesticated life. Man meets Woman, and they begin a life together in 'a nice dry Cave'. They are joined by Dog, Cat, Horse and Cow, and all of the animals quickly become tame and offer their services to the humans in exchange for food – all, that is, except for the cat. 'I am not a friend and I am not a servant. I am the Cat who walks by himself and all places are alike to me.'

One day the cat smells 'warm white milk' and presents himself at the cave, but the Woman refuses to feed him. Eventually the Cat bargains with her, and in exchange for milk and a place by the fire, he amuses her baby, then lulls it to sleep with his purring, and finally catches a mouse in the cave. Kipling's point of course is that the cat would have done all these things anyway, and has made absolutely no concessions in order to get what he wants. He is, and always will be, a free spirit, going where and when it pleases, a symbol of man's vicarious sense of freedom from social conventions and lack of subservience.

The Boy Who Drew Cats

This beautiful English edition of the Japanese folk tale 'The Boy Who Drew Cats' dates from 1905. Printed on delicate crêpe paper, it tells the story of a young boy who, despite his apprenticeship to become a priest, cannot stop drawing pictures of cats on every surface he can find. Eventually his subversive artistic behaviour leads to his dismissal from the priesthood, and he is sent away. Sheltering in a strangely deserted temple he finds blank walls and screens, which he promptly covers with enormous drawings of cats, before falling asleep in an anteroom of the temple. During the night he hears terrible screams and crashes, and in the morning on the floor of the temple is a huge dead goblin-rat, which unbeknown to him has been terrorising the village. His drawings of cats, meanwhile, have all mysteriously acquired blood-red marks around their mouths.

Many Japanese folk tales were first translated into English by Lafcadio Hearn, a writer who eventually settled in Japan and became a Japanese citizen, taking the name Koizumi Yakumo. Hearn got nearer perhaps than any other Western writer to understanding the Japanese, and his stories have a subtle charm typical of their cultural source.

The book was published in 1898 by Takejiro Hasegawa, and bound in the traditional Japanese bookbinding style known as 'fukuro-toji' or pouch binding, which produces folded pages which are open at the top and bottom, thus forming the pouch. Hasegawa employed a number of artists, and although the name of the illustrator for this edition is not certain, one of the pictures is signed 'Kason' which indicates that it may well be Kason Suzuki, one of the most renowned painters of nineteenth-century Japan.

Opposite: THE COVER OF THE 1905 EDITION OF
'THE BOY WHO DREW CATS' BY LAFCADIO HEARN
Overleaf: THE BOY WHO CANNOT STOP DRAWING CATS
(He has drawn cats on the screen, and is about to be banished from the temple)

JAPANESE FAIRY TALE SERIES No 23

THE BOY WHO DREW CATS

Rendered into English
By
LAFCADIO HEARN

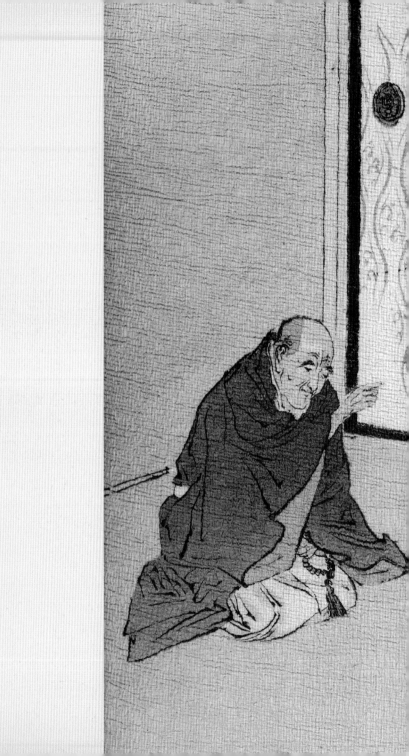

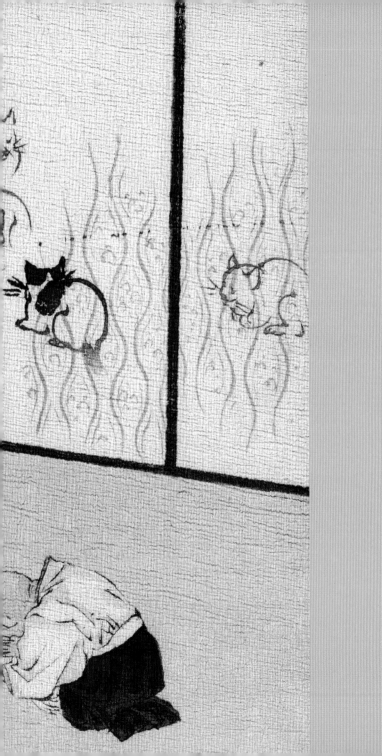

The Cat in the Hat

BY *Dr Seuss*

Children love the idea of a magical person or animal coming into their lives which enables them to live a secret existence in the midst of everyday activity. A perfect example is the classic rhyming story of *The Cat in the Hat* by Dr Seuss in which two children find their boring afternoon is overturned by the arrival of an eccentric creature who walks and talks like a human being, but who looks like a cat – albeit one in an oversized bow tie and a red-and-white striped hat. The sense of empowerment the children gain from being the only ones to know about this enchanted animal is counterbalanced by the chaos he threatens to bring to their normally well-regulated household. However, Seuss perfectly understood the anxieties of small children, and in his capable hands, the story of the cat's afternoon in their previously well-ordered household takes flight to become a tale of magic and fun:

> 'Have no fear of this mess!'
> Said the Cat in the Hat.
> 'I always pick up all my playthings
> And so...
> I will show you another
> Good trick that I know! '

The Cat in the Hat was Seuss' thirteenth book, and was published in 1957, twenty years after his first book, *It Happened on Mulberry Street*. He was by that time a highly respected children's author, but his success was hard-earned. He had, by his own admission, a tough childhood: as the child of German immigrants he was bullied at school, instilling in him a sense of social injustice

Opposite: THE CAT IN THE HAT FINDS LOTS MORE CATS
From *The Cat in the Hat Comes Back* by Dr Seuss, Random House, 1958

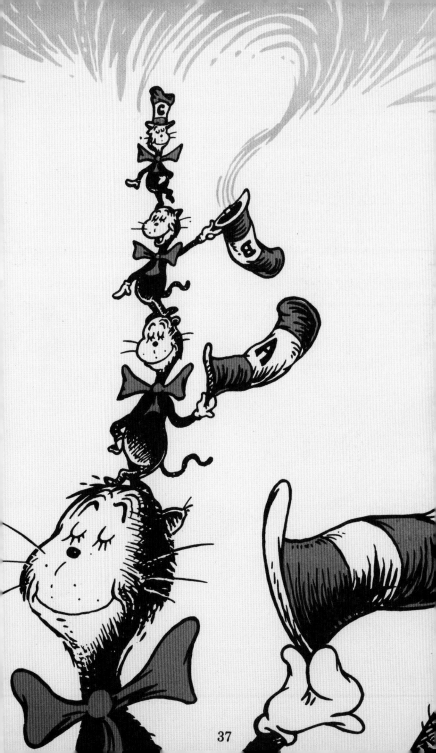

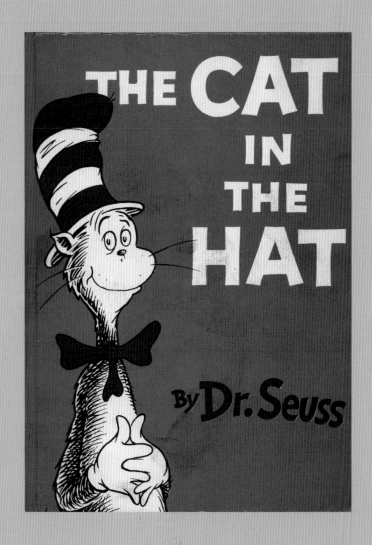

Above: THE FRONT COVER OF THE ORIGINAL EDITION OF
The Cat in the Hat BY DR SEUSS
Random House, 1957

that would permeate all his writing. After a failed PhD at Oxford University, Seuss returned to America, where he became an advertising writer and illustrator. During the Second World War Seuss worked on animated films for the US army, after which he returned to writing books for children.

In 1954 whilst under contract to Random House he had dinner with the director of the educational publisher Houghton Mifflin. The conversation turned to the subject of children's literacy, and in particular why current reading books (or primers) were not helping children develop into enthusiastic readers. As a result Seuss was challenged to write a book 'that first graders can't put down', furthermore he was restricted to a vocabulary of 348 words that a six-year-old should know. Nine months later he delivered *The Cat in the Hat*, using 223 of the words on the list, (plus thirteen that were not). The book was a runaway success, and by 1960 had sold over a million copies. It was soon followed by *The Cat in the Hat Comes Back*, and *Green Eggs and Ham*, and dozens more books that have delighted generations of young readers.

Seuss never lost sight of the importance of children's literacy. As he wrote in an essay published in 1960:

> ...children's reading and children's thinking are the rock-bottom base upon which this country will rise. Or not rise. In these days of tension and confusion, writers are beginning to realize that books for children have a greater potential for good or evil than any other form of literature on earth.

Old Possum's Book of Practical Cats

Cats appear in various ways within the poems and letters of T. S. Eliot. In his 1930 poem 'The Love Song of J. Alfred Prufrock', he likened the yellow fog of St Louis to a cat: 'that rubs its back upon the window panes', and in January 1931 he wrote to his nine-year-old godson Tom Faber to say that 'I am glad you have a cat, but I do not believe that it is so remarkable a cat as my cat...there never was such a Lilliecat. Its name is Jellylorum, and its one idea is to be useful.'

Eliot gave himself the assumed name of 'Old Possum' to his godchildren (his Preface to the book is signed O.P.) and delighted in imagining names for cats of his friends and colleagues. His widow Valerie Eliot recalled 'I remember Noilly Prat (an elegant cat); Carbuckety (a knock-about cat) and Sillabub, a mixture of silly and Beelzebub'.

Most of the poems for *Old Possum's Book of Practical Cats* were written between 1936 and 1938, and some came to him more easily than others. 'I have done a new cat, modelled on the late Professor Moriarty' he wrote, 'but he doesn't seem very popular, too sophisticated perhaps.' The finished poem was of course the infamous Macavity: the Mystery Cat, 'a fiend in feline shape, a monster of depravity.'

Originally Eliot intended to produce a book of poems about cats and dogs, and his publisher Faber and Faber duly announced the publication of 'Mr Eliot's book of *Pollicle Dogs and Jellicle Cats*' in their catalogue for Spring 1936. But the concept ran into difficulties, and Geoffrey Faber wrote that there was 'a growing perception that it would be impolite to wrap cats up with dogs'. So it was that three years later *Old Possum's Book of Practical Cats* was published, with a print run of 3005 copies and priced at three shillings and sixpence. Eliot's own drawings appeared on the dustjacket, but these were superseded by the more recognisable

THE NAMING OF CATS REQUIRES CONSIDERABLE THOUGHT
Old Possum's Book of Practical Cats with colour plates
by Nicolas Bentley, Faber and Faber, 1939

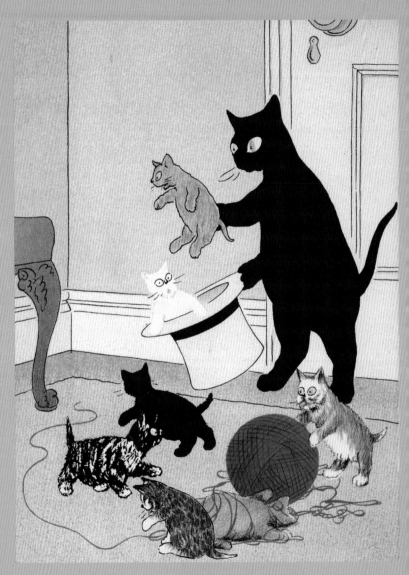

Above: Mr Mistoffelees, the mysterious 'original conjuring cat' who is always deceiving you into believing he's only hunting for mice'

Opposite: Mungojerrie and Rumpelteazer

drawings by Nicolas Bentley, a well-known magazine illustrator who had also illustrated books such as Hilaire Belloc's *Cautionary Tales* in 1930.

Eliot was originally uncertain about the wisdom of publishing such a light-hearted book, given his somewhat austere reputation as an intellectual: 'It is intended for a new public' he wrote, 'but I am afraid I cannot dispense with the old one'. His worries were unfounded. 'Cats are giving general satisfaction' reported the Faber sales manager, and the newspaper reviewers were equally appreciative of the way he had captured the personality of the cats 'in the finite variety of human nature' as the *Manchester Guardian* reported.

A small postscript to T. S. Eliot's feline legacy came in 1991 when the British Library acquired a collection of letters and two previously unpublished poems that had belonged to his goddaughter Anthea Tandy. They included the poem 'The Practical Cat' which he described in one of the letters as 'A minor OPUSS' and some words of wisdom that will be recognised by cat owners young and old: 'When a Cat adopts you' he advised, 'there is nothing to be done except to put up with it and wait until the wind changes.'

Orlando the Marmalade Cat

Orlando was very beautiful, striped like marmalade and the same colour; his eyes reminded you of twin green gooseberries.

Many can remember reading the Orlando books, and dog-eared copies have been passed from one generation to the next. Their very large size made it easy to quite literally creep behind the covers and delight in the bright chalky pictures and simply-told adventures of Orlando, his tabby wife Grace and their three kittens, Pansy, Blanche and Tinkle. To small children, their adventurous life seemed idyllic, and for adults, the nostalgic world they depicted was a comfort in the increasingly troubled late 1930s, as Britain moved towards war.

But the creator of the books, Kathleen Hale, remained ambivalent about her famous creation, and the way his popularity kept her from achieving her artistic potential. 'He took me over', she recalled at the end of her life, 'I was besotted with him. For over ten years I had no social life, I did nothing else at all.' This was absolutely true – not only did Hale write the stories and create the illustrations, she also prepared the four-colour lithographic zinc printing plates on her kitchen table at home. Each book had 32 pages, which meant preparing 128 zinc plates, a process that took four to five months, working seven hours a day, seven days a week, at the same time as running her household and looking after her two small sons.

Her drawings of Orlando and his family were based on her own cats, and she also made use of an x-ray of a cat skeleton to help understand the articulation of the bones, and to realise 'the spontaneity of line...They're very difficult to draw because they're fluid. You don't see the bones.' The people and animals in the books were often drawn directly from her own experiences, for example *Orlando Buys a Farm* (1942) was based on her time as a Land Girl in the First World War, and *Orlando's Trip Abroad* came

The illustrations in this book have been drawn direct by the Author on 'Plastocowell', a transparent plastic material used in lithography and lithographed in Great Britain by W. S. Cowell Ltd, at their press in the Butter Market, Ipswich

PUBLISHED IN 1952 BY COUNTRY LIFE LIMITED, TAVISTOCK STREET, COVENT GARDEN, LONDON, W.C.2

2

ORLANDO, HIS WIFE GRACE AND THEIR KITTENS REALISE THAT THEY NEED A HOLIDAY
Kathleen Hale cleverly composed every picture so that each cat was clearly visible.
From *A Seaside Holiday*, written and illustrated by Kathleen Hale,
Country Life Ltd, 1952

from the time she spent in France in the 1920s with a shell-shocked lover. She also worked for a short time for Duncan Grant and Vanessa Bell, and was secretary to Augustus John for just over a year. It was working in these artistic circles that led to a meeting with Noel Carrington (brother of Dora) who was then editor of the magazine *Country Life*. Carrington saw the potential of the Orlando stories, with their celebrations of village England and family life, and he published the first five books, starting in 1938 with *Orlando the Marmalade Cat: A Camping Holiday*. Voracious demand for the stories led to their being published by the very new Puffin Picture Books, and eventually there were eighteen books featuring Orlando, the last published in 1972.

Despite being celebrated as one of the greatest children's writers and illustrators of the twentieth century (she died in January 2000 aged 101) Kathleen Hale was very candid about the popularity of the books:

For some days the animals were so st their work. However, Orlando allowed easier for them.
It was harvest time and the men decl

22

> I remember thinking after eight, this is getting vulgar. One ought to be famous for one or two books like *The Wind in the Willows* or *Alice in Wonderland*.

y could not bend to
edals, which made it

a "bumper crop."

Grace put on dungarees to protect herself from the prickly stubble. The Kittens dressed up as Red Indians. Blanche borrowed a Japanese doll and a saucepan from Mrs. Butterfield, and was the squaw. Tinkle and Pansy went scalp-hunting among the field-mice. Orlando snatched a well-earned snooze.

23

ORLANDO TAKES A BREAK WHILST HIS WIFE
CONTINUES TO TOIL IN THE FIELDS
A scene based on Kathleen Hale's own experience as a
Land Girl in the Second World War.
From *Orlando Buys a Farm*, Country Life Ltd, 1942.

Fat Freddy's Cat

The ultimate 'cool cat', Fat Freddy's cat is the definitive manifestation of feline freedom. A tough ginger tomcat with a bottlebrush tail, he lives in San Francisco with the Fabulous Furry Freak Brothers, a trio of hippies who spend their days listening to rock music, smoking dope, and trying to avoid both gainful employment and the law.

Fat Freddy's cat is smart. The indolent drug-addled lifestyle of his owner means that he has to be constantly resourceful in search of food, for example playing Jimi Hendrix at full volume in the morning in order to wake up Freddy and get him breakfast. When not in search of food, or a place to defecate (usually Fat Freddy's headphones) he is waging a one-cat war against

the army of cockroaches infesting the Freak Brothers' filthy kitchen. He is also – like most fictional cats – always prepared to outsmart the rather dim neighbourhood dog, who is usually pretty easy to humiliate, although he is in turn subjected to undignified abuse from his three young nephews whenever they call round. They are the only ones who refer to him by any kind of name, when they call him Uncle F.

A product of the extensive hippy subculture which grew up in the late 1960s, Gilbert Shelton's work had appeared in underground magazines and newspapers before the first

of the Fabulous Furry Freak Brothers shambled into print in 1967 as a comic strip in the *Austin Rag*, an underground newspaper which was syndicated in similar alternative publications. In 1968 Shelton issued *Feds 'n Heads*: a comic book featuring the Freak Brothers, put together in a garage, which sold for 35 cents a copy. Soon afterwards he moved to San Francisco and co-founded Rip Off Comics which published all subsequent editions of the Fabulous Furry Freak Brothers.

Initially Fat Freddy's cat appeared in a small strip at the bottom of the page of the main story, but as has often been the case with cartoon animals, the readers enjoyed him so much that he soon had his own comic strip, which eventually was published in four books as *The Adventures of Fat Freddy's Cat*, in the 1970s, then revised and expanded into six books in the 1980s. And despite the hippy backdrop, the stories of a capable and inventive cat outsmarting his slow-witted owner remain timeless and amusing examples of the comic medium.

Opposite: THE REAR VIEW OF FAT FREDDY'S CAT, UNMISTAKEABLY MALE
From *The Collected Adventures of Fat Freddy's Cat and His Friends* by Gilbert Shelton,
Rip Off Press, 1975

Above: CHASING MICE? I'M DANCING THE FANDANGO
Freddy's Cat explains his curious moves whilst sleeping

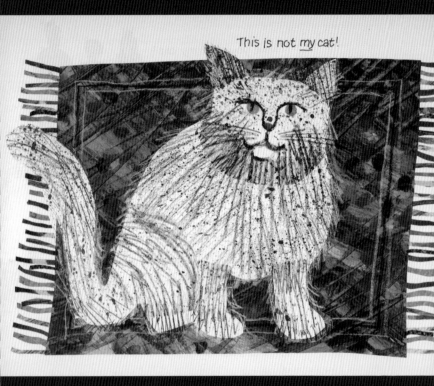

SEATED ON AN EXOTIC BLUE RUG, THE PERSIAN CAT (WHICH IS 'NOT MY CAT!')
From *Have You Seen My Cat?* by Eric Carle, Franklin Watts, 1973

Have You Seen My Cat?

BY *Eric Carle*

The distinctive style of an Eric Carle illustration is instantly recognisable from any of his picture books. His technique is to use tissue paper, which is then coloured with acrylic paints and layered to create a collage effect. As well as being so easily identifiable, the creative process is one that young children can easily try for themselves, and is useful in demonstrating how colours can be blended to make new shades and tones.

Eric Carle has written and illustrated over seventy books, almost all of them about animals and insects:

> This love and curiosity ...had been awakened by my
> father. He'd take me on walks through meadows and
> woods, and explain as we explored, the often peculiar life
> cycles of these small creatures that we had discovered.

It is this sense of curiosity and discovery which makes his books so appealing to young readers, and has resulted in sales of his books of over 110 million copies in more than fifty languages.

Although born in New York, Eric and his family moved to Germany in 1935 when he was six years old. It was not an idyllic childhood, although his artistic imagination was stimulated by his art teacher, who managed to show him examples of 'degenerate' art by Klee, Matisse and Picasso. Carle returned to America as a young man in 1952, with – in the best tradition of rags to riches – forty dollars in his pocket. He found work as a graphic designer, and went on to become art director at an advertising agency. His move into books came when author Bill Martin Jr saw an illustration of a lobster that Carle had made for an advertisement, and he suggested that Carle produce the illustrations for his book *Brown Bear, Brown Bear, What Do You See?* The collaboration resulted in a classic book,

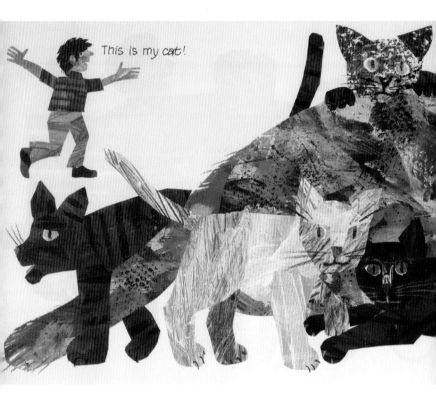

published in 1967, which is still a favourite with children.

Carle quickly started to write and illustrate his own stories, based on the animals and insects that had fascinated him as a child, most famously *The Very Hungry Caterpillar* which was published in 1969. His 1973 title *Have You Seen My Cat?* Is a typical 'lost and found' story that addresses children's fear of losing something precious to them. An umnamed little boy in the story travels around the world in search of his nameless cat, and on his travels sees a variety of breeds of cat, including lions, cheetahs and panthers. The repetitive phrase by the boy of "Have you seen

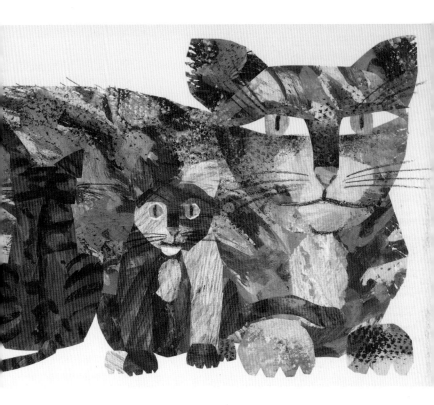

my cat?" is always followed by his response "This is not my cat".
The clever twist comes at the very end of the book, when he finds
his pet again and the reader discovers that the little boy's cat
has now become 'cats'.

Above: THE REASON FOR THE DISAPPEARANCE OF THE CAT BECOMES CLEAR:
SHE HAS HAD KITTENS
From *Have You Seen My Cat?* by Eric Carle, Franklin Watts, 1973

101 Uses of a Dead Cat

Given the unprecedented levels of popularity that cats enjoy in western society, the publication of Simon Bond's book *101 Uses of a Dead Cat* in 1981 was eccentric, to say the least, and many people regarded his sense of humour as callous and cruel. But the bizarre and ridiculous nature of his dead cat cartoons (cats as golf clubs, foot stools, toast racks and roller skates) took the concept to an absurd level that was impossible to take seriously, and it became one of the great comic creations of the 1980s.

The critics recognised the cleverness of the concept, although they also saw how offensive it could be. 'Sick, wrong, hilarious' was a typical reaction, and *Time* magazine described Simon Bond as the 'Charles Adams of ailurophobia'. (Ailurophobia is the persistent and irrational fear of cats). This comparison to the great American humourist of the macabre was perhaps valid, given the consistently dark tone of Bond's work, and although not afraid of cats (he owned four) he was allergic to their fur.

Bond's first book *Real Funny* appeared in 1976, and soon afterwards in London he mentioned the idea of the dead cat book to his friend Terry Jones, of Monty Python. Jones in turn put forward the idea to his publisher, Methuen, who had a well-established list of humour titles including Thelwell (pony cartoons), Steve Bell (politics) and several Monty Python books. Methuen liked the idea and the book *101 Uses of a Dead Cat* was published in 1981 (in America the title was slightly amended to *101 Uses for a Dead Cat*). Despite the strong reaction to the book, it was an immediate international success, and went on to sell over two million copies in twenty countries.

After the inevitable follow-up *101 More Uses of a Dead Cat*, and various calendars and other spin-offs, Bond went on to publish more than twenty collections of drawings. His last published book was *101 Uses of a Dead Roach* (2002). But nothing ever matched the success of his small book about cats.

Above: BIZARRE AND RIDICULOUS, THE MANY USES OF A DEAD CAT
Illustrated by Simon Bond, *101 Uses of a Dead Cat*, Methuen Books, 1981

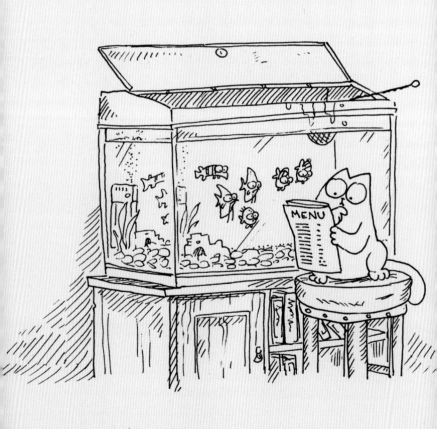

Simon's Cat

Simon's Cat began as a series of short cartoons, available to be viewed through *YouTube*. The deceptively simple black-and-white line animations feature a rather fat cat with staring eyes and poor co-ordination, who uses increasingly heavy-handed tactics in order to gain his owner's attention. When not cadging food, the portly cat spends its time devising ploys to catch birds, mice and fish from his owner's pond, although he is not above annoying the local hedgehog by impaling leaves, apples and tennis balls on its prickles.

The cartoons became a viral phenomenon, with over thirty million hits in one year, and in 2009 the first book based on the popular animated series was published by Canongate. The wordless cartoons are based on artist and animator Simon Tofield's own four cats, and he has said that the cartoon cat deliberately has no name as it helps the reader 'to connect to Simon's cat, imagining it being similar to their own cat'. The lack of language in the feline tales has enabled the stories to be instantly understood in any language, and the books are one of the few examples of an internet meme transferring successfully to book format.

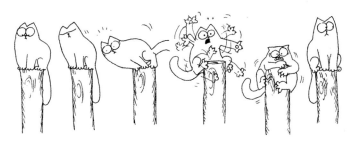

SIMON'S CAT, WHOSE BEHAVIOUR IS EASILY IDENTIFIABLE TO EVERYONE
THAT HAS WATCHED A CAT
From *Simon's Cat* by Simon Tofield, Canongate Books, 2009

Splat the Cat

Splat the Cat burst into print in 2004. A lively fat black cat, with fuzzy fur, spindly legs and a tail that has a mind of its own, he was inspired by a cat that author and artist Rob Scotton remembered from his childhood: 'an old balding snaggly-toothed cat that lived next door to me. I used to call it Ninja'. However Splat, like his readers, is young, adventurous, and frequently faced with new and challenging situations that he must learn to overcome. In the first story, Splat has to go to school, an event that all children need to face. Splat is not happy, 'his tail wiggled wildly with worry', and he does his best to put off having to go:

> 'I don't have any clean socks Mum. Maybe I should go to school tomorrow instead?' Splat said.
> 'You don't wear socks' said his mum.

Even once he sets off for school, the gate 'won't let go of my fingers', and he puts his pet mouse, Seymour, into his lunch box, so that he has a friend to talk to. Of course his fears are unfounded, and Splat is soon looking forward to his second day at school.

Scotton's bright and energetic illustrations lead the young reader through the many stories, but he is clever enough to include subtle details to amuse the adult who may be reading the story to the child. Splat's alarm clock always points to 'too early' and the books on his bookshelf include *Dogs are from Mars, Cats are from Venus*.

Opposite: STARING EYES, FROZEN LIMBS AND A CRAZILY FUZZY TAIL:
POOR SPLAT REALLY DOES NOT WANT TO GO TO SCHOOL
From *Splat the Cat* by Rob Scotton, HarperCollins, 2004

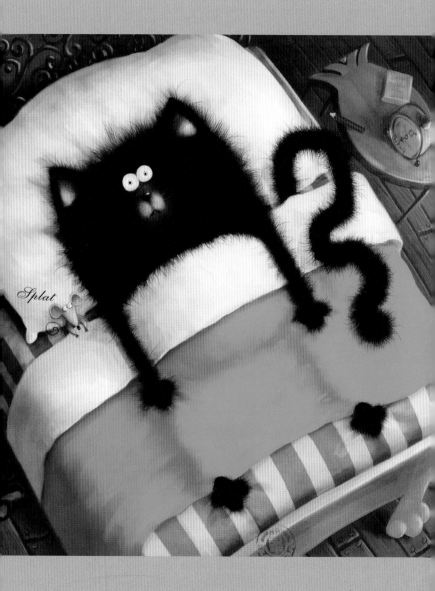

Splat

Index

The author and publisher are grateful to all copyright owners who have given permission to reproduce illustrations in this book. We have used our best endeavours to obtain permissions where necessary, and will of course correct any errors or omissions in further editions.

Illustrated on half-title page
AN ENGRAVING OF THE DOMESTIC CAT
By Thomas Bewick from his *History of Quadrupeds*, published in Newcastle in 1790

Title page
THIS IS THE CAT THAT KILLED THE RAT...
An illustration from an 1895 one penny edition of *The House That Jack Built*

Pages 4 & 5
THE STORM CAT AND MOWZER
From *The Mousehole Cat* by Antonia Barber, illustrated by Nicola Bayley,
Walker Books, 1991

I wish to acknowledge Andrew Barron who has done so much to
present the cats in this book so colourfully and creatively. Thank you also to
Sally Nicholls for her work in sourcing the images, and for some great suggestions.
David Way has encouraged and supported this project,
for which I am grateful. My love and thanks to my husband Gerald, who has
tolerated the loss of our dining room table under piles of research material whilst
this book was in progress. *Puss in Books* is dedicated to my sister Joanne, who has
owned and cared for almost as many cats are there are in this book.

First published 2012 by
The British Library
96 Euston Road, London NW1 2DB
www.bl.uk

Text © 2012 Catherine Britton
Illustrations © The British Library Board and other named copyright holders

British Library Cataloguing-in-Publication Data
A catalogue record for this book is available from The British Library

ISBN 978 07123 5882 8

Designed by Andrew Barron @ thextension
Printed and bound in Hong Kong by Great Wall Printing Co. Ltd